Painting
the Secret World
of Nature

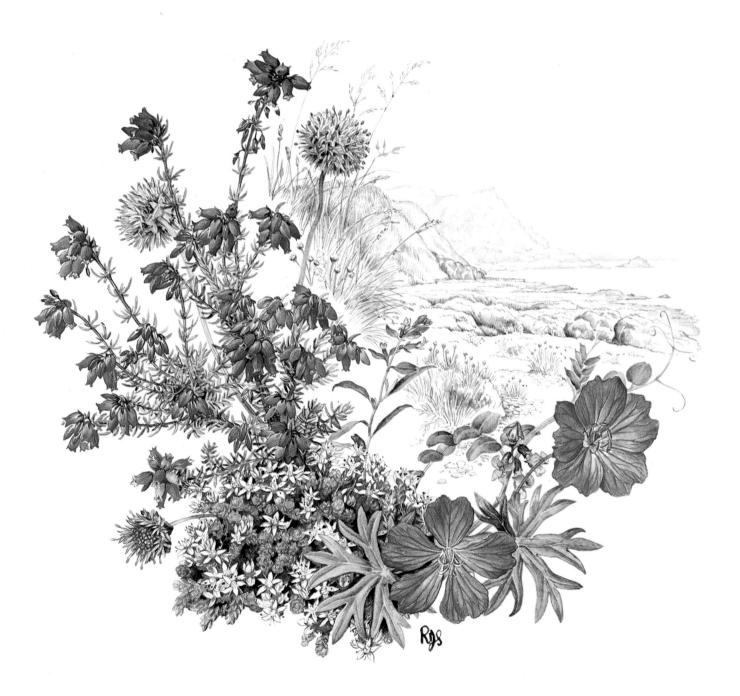

Painting
the Secret World
of Nature

Sylvia Frattini **James Lester**
Benjamin Perkins **Rosanne Sanders**

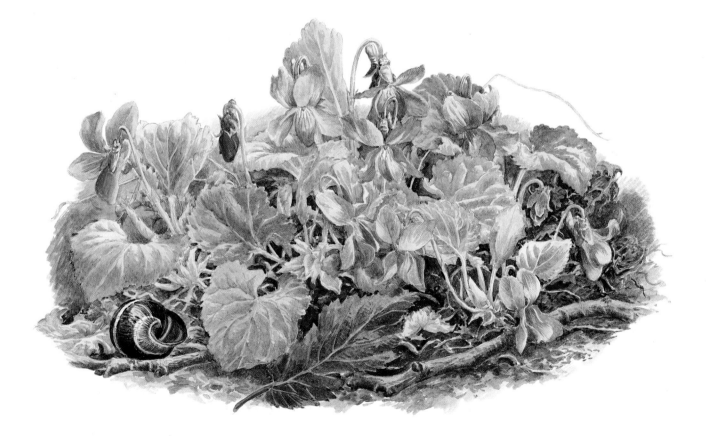

SEARCH PRESS LIMITED

First published in 1987

by Search Press Ltd
Wellwood, North Farm Road,
Tunbridge Wells, Kent TN2 3DR, England

in association with
Watson-Guptill Publications Inc.
1515 Broadway
New York, N.Y. 10036

Note Since the original book was published as a collaboration
between the British publisher and an American publisher, the
text sometimes follows American spelling and usage.

ISBN (UK) 0 85532 585 2

Typeset by Phoenix Photosetting, Chatham.
Origination by Adroit Photo Litho, Birmingham.
Printed in Hong Kong by Everbest Printing Co., Ltd.

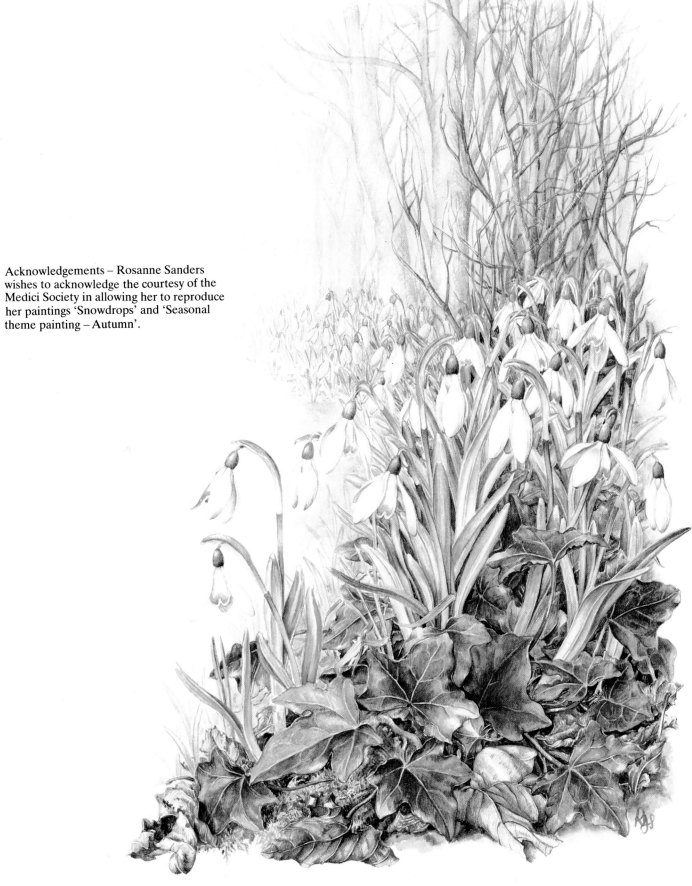

Acknowledgements – Rosanne Sanders wishes to acknowledge the courtesy of the Medici Society in allowing her to reproduce her paintings 'Snowdrops' and 'Seasonal theme painting – Autumn'.

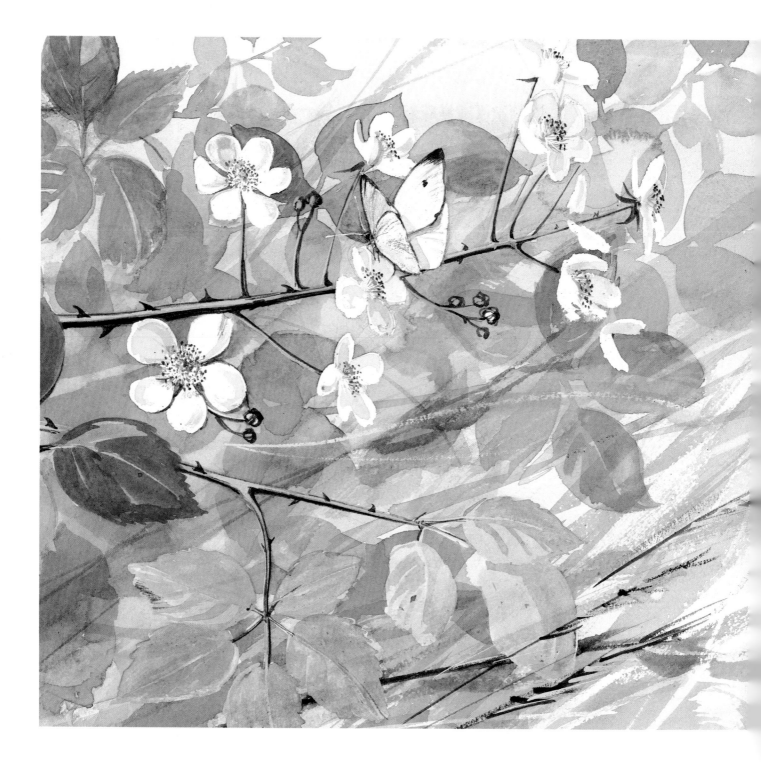

Contents

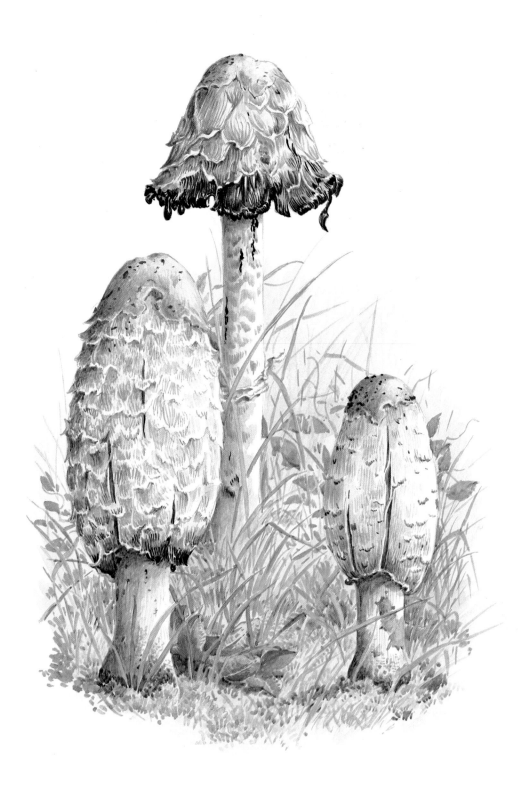

Preface

Painting the Enchanting World of Nature is much more than a compilation of four distinguished British artists' work. The artists – Sylvia Frattini, James Lester, Benjamin Perkins, and Rosanne Sanders – were all specifically invited to discover, draw, and paint the fascinating small surprises in the natural world around them. They set out to capture the tiny detail, the fallen leaf, the budding flower or bulb. The idea was to portray, not broad land-scapes or animal life, but the enchanting, hidden world of hedgerows and garden borders, with their miniature panoramas of flowers, weeds, mush-rooms, and insects – something the human eye all too often fails to see.

Although each artist was given the same instructions, the results are diverse. It is particularly interesting to compare the way different artists have handled a similar subject, like poppies or snowdrops. As James Lester comments, it is important to express your own feelings about what you see. Looking at the individual styles of the artists in this book and learning about their different methods should encourage you to experiment on your own.

Sylvia Frattini
Exploring the detail of nature

Ever since I can remember I have sketched and painted, using a variety of media. But only during the last five years have I painted solely in watercolor. At first I worked one hour each day, but I gradually increased this to five hours, during the evenings and on weekends. Because I am fanatical about detail, I spend many hours on each work. During the year, therefore, I produce only a few paintings, and most of them are quite small.

I was brought up in the north-west of England, in the hills of the Cumbrian countryside. My interests have remained there, and landscapes and sheep feature in much of my work. I am interested in all aspects of nature, particularly wild flowers and birds.

With the limited time I have to record information for my work, my camera is an essential aid, and I am seldom without it. Wherever possible, however, I back up the photo references with sketches and color notes. I also collect interesting and unusual objects, which I sometimes include in my paintings.

For the paintings in this book, I made many plans and sketches so that I knew exactly what to put down and did not need to make more than a few adjustments. When you look at my demonstration paintings, you may find that they could be regarded as complete at the penultimate stage. The final stage depends on the amount of detail one wants. As I say, I am fanatical about detail.

Method and materials

The painting of detail in landscape calls for very precise control of your materials. For me this means using watercolors more opaquely when I want the form to be exact. I tend to thicken my transparent tints with Chinese white, varying this according to the required tone. I also build my washes in deepening layers. This is a safe method of painting, but it is important to keep your mixes pure. I suggest that you use a compartmented palette, as well as separate bowls for broad areas of a single color.

I use pointed sable brushes, ranging in size from no. 00 to nos. 5 or 6, plus a one-inch square sable for large washes. I do not paint with nylon brushes, although I do use them for mixing colors. Always treat your brushes with respect; they will lose their shape and suppleness if they are left overnight in a jar of water.

Unlike most watercolor painters, I use many colors and work from several different palettes. With my special interest in the countryside, however, it is green that usually predominates. The colors I have used for the demonstrations in this book include white, black, sepia, burnt umber, cobalt violet, cobalt blue, Prussian blue, turquoise, lemon yellow, cadmium yellow, yellow ochre, light red, Venetian red, orange, leaf green, Hooker's green (dark), and raw sienna. From these hues I have mixed various tints, such as gray or maroon, which are also mentioned in the text.

For paper, I prefer to use a cream-based Ingres paper, since I find that white papers dazzle me. I stretch the paper before painting on it. For sketching I never use pencils; a very fine pen gives me more control.

Several painting techniques I use seem worth noting here. The principle of painting light to dark should be obvious: since you cannot erase watercolor without unsightly rubbing (unless you lift the wash immediately), it makes sense to lay in your basic tints lightly, then deepen them where necessary once the first wash is dry.

Painting wet into wet allows me to keep edges soft and blend tints subtly (especially in skies, water, and distances). In contrast, the drybrush technique, when I use little or no water with my paint, produces a rough, grainy texture, suitable for bark or stonework. This is a technique, however, that I prefer to use only at the final stage.

I also at times use stippling, applying tiny dabs of paint with the tip of a pointed brush to build an interesting and colorful effect. This method was a favorite of the Victorian watercolorists, as well as of Seurat and the French pointillists.

Underlying all these techniques is drawing. Always sketch, when possible, from an actual model, whether a single plant or a general composition. Analyze the structure or form, be it the skeletal structure of flowers and leaves or broad masses of terrain or rock formations. Do not niggle, but try to develop a bold, rhythmic use of line, working from the wrist and capturing nature's grace, which reveals itself in all organic growth. And never throw away an honest sketch; the time will come when you will find a good use for it!

Flowering water lilies

Size: 8¾ × 8¾ inches (220 × 220mm)
Paper: Ingres Fabriano 90lb. (160gsm)
Brushes: sable nos. 00, 0, 1, 5

I discovered this subject – a lily pond – by chance when I was visiting friends one summer. What attracted me to it were the sweeping patterns and the movement created by the large, multicolored leaves. The beautiful lilies, some almost hidden, just appearing from underneath the leaves, gave added interest.

On this visit I did not do any preliminary sketches but photographed the pond from several angles. Some time later, when I decided to use this theme for a painting about summer, I returned to the pond to make sketches – only to find that it had been cleared. I have had to rely, therefore, entirely on my photographs. At first I wanted to include some of the frogs living in the pond, but decided to leave them out.

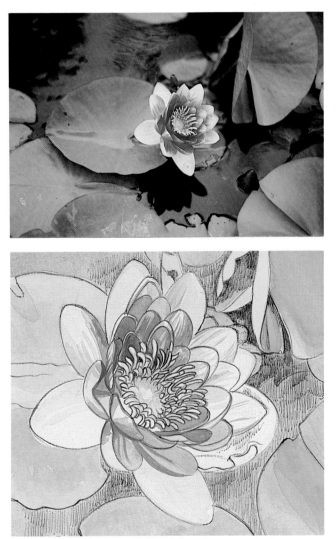

Study of pink lily, made from the photograph above

Preliminary work

Before any paint is applied, careful planning is needed to establish the correct proportions of the leaves and flowers and to develop the complicated composition. I find that the areas of water and the shadows make a pleasing contrast to the plants.

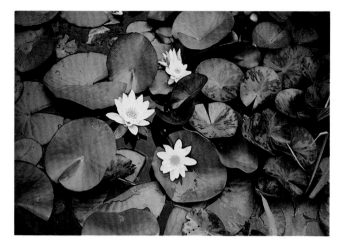

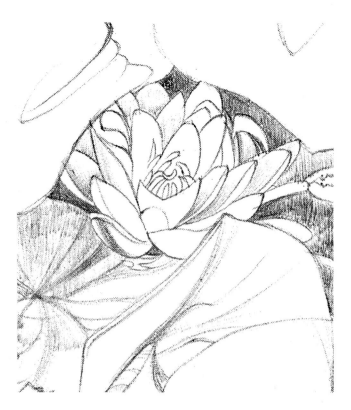

Photograph of water lilies (above) with (right and below) contour drawings of water lilies and leaves which begin to describe the tone of variations of water and shadow.

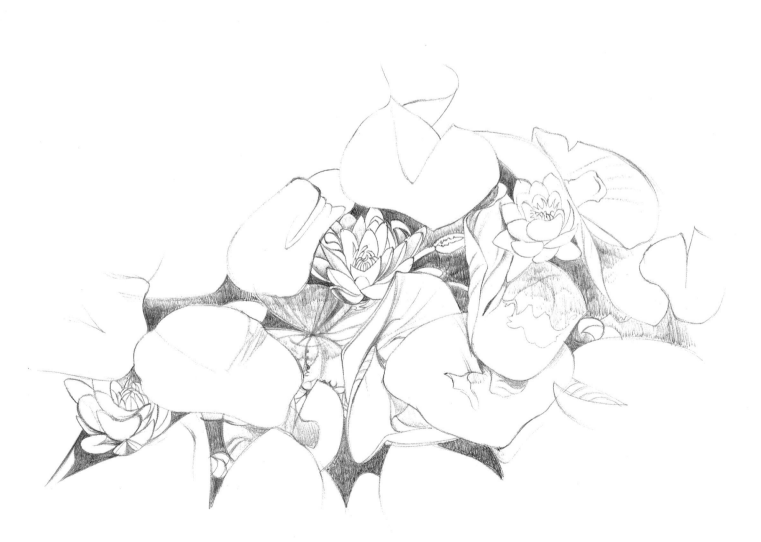

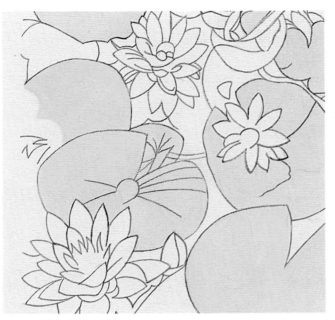

Stage 1 (detail)

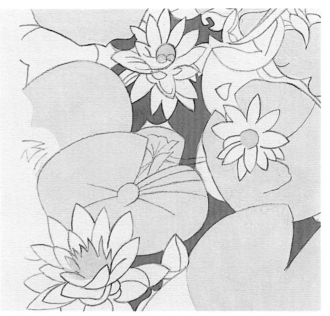

Stage 2 (detail)

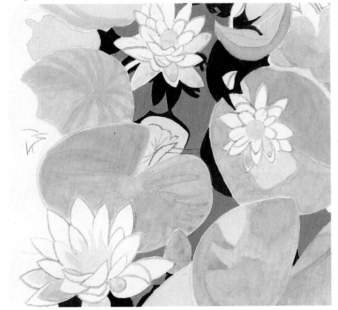

Stage 3 (detail)

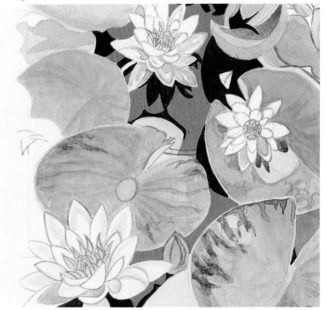

Stage 4 (detail)

Stage 1

After outlining the flowers and leaves in pencil, I begin working into the leaves with a basic color wash, mixed from Hooker's green and white, and applied with a no. 5 brush.

Stage 2

Keeping the paint thin and using a no. 1 brush, I fill in the flower petals with a very pale mixture of white and yellow. With the same brush, I dab a light yellow mixture into the center of the flowers. I then block in the water areas using a mixture of Prussian blue, black, and white, and a no. 0 brush.

Stage 3

With my no. 0 brush, I fill in the shadow areas in the water with a deeper tone than the water itself. Then I begin to work into the petals and leaves. Working from light to dark, I make the deepest shadows on the petals that are covered by water.

Stage 4

I continue to work on the leaves and petals with a fine brush and gradually strengthen all the colors. For the detail on some of the leaves, I use a mixture of violet and cobalt blue.

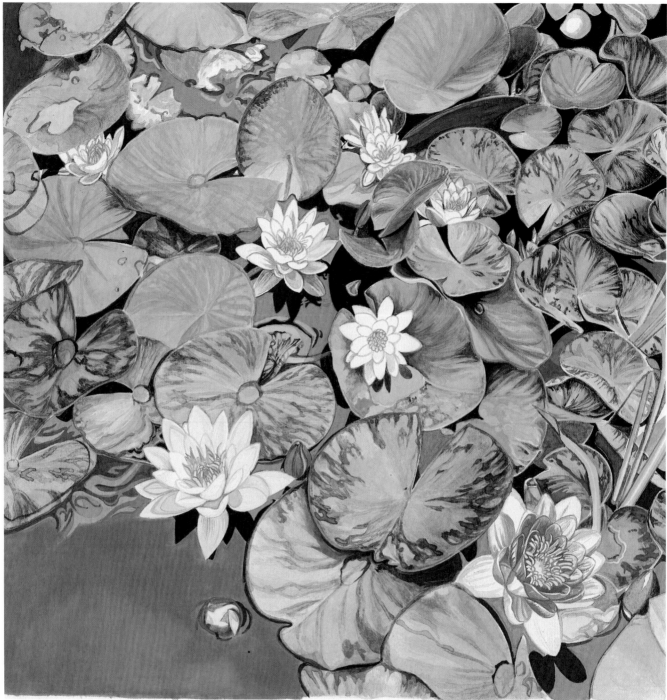

Stage 5 – the finished painting

Stage 5 – the finished painting

With the point of a no. 00 brush, I now work meticulously into the leaves. I use very fine lines to make the flowers look more realistic. Then comes the most difficult part in this picture: painting the water that has gathered inside some of the leaves. By using Chinese white semi-transparently, I am able to suggest the droplets on the surface of the leaves.

Spring promise

Size: 14 × 17 inches (350 × 450mm)
Paper: Ingres Fabriano 90lb. (160gsm)
Brushes: sable nos. 0, 1, 3, 5, large flat

The scene at the bottom of my own garden gave me the inspiration for this picture, one of the largest paintings I have ever done in watercolor. I spent more than three hundred hours working on it. As I knew from the start it would take a long time to complete, I planned it over a two-year period, giving it a considerable amount of thought before I put brush to paper. I also made many sketches and took numerous rolls of film.

Although this painting was done entirely in my studio, I worked wherever possible from nature. I planted some of the weeds and painted the flower heads in the spring. Fortunately I had access to red dead-nettles and goose grass throughout the winter months.

Study of daffodils and narcissus

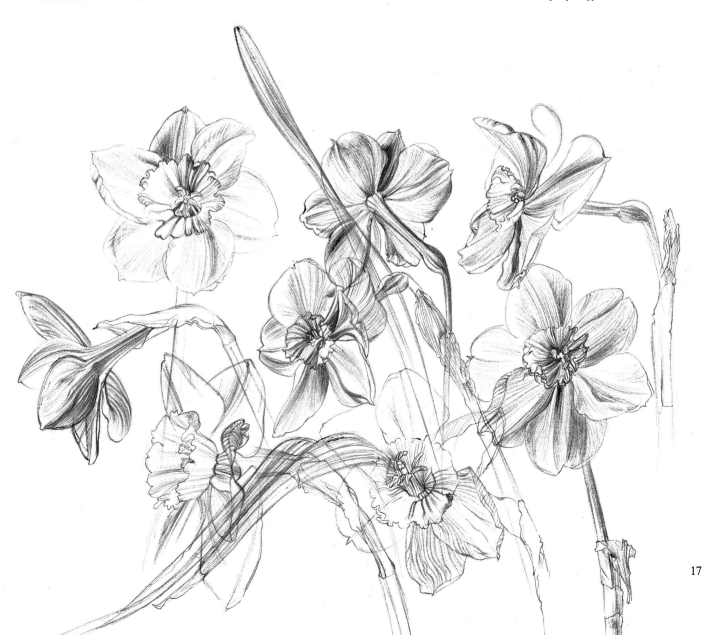

Basic layout sketch drawn from photograph below

Preliminary work

I begin with a basic sketch of daffodil leaves, red dead-nettles, and goose grass. Next I draw the daffodils and narcissus, and introduce them into the basic sketch. This arrangement presents the biggest problem. To help visualize the arrangement, I cut out pieces of paper representing the flowers' heads and place these in varying positions on the sketch.

After these preliminaries, I start gathering information for the remainder of the painting, making sketches of primrose leaves, chickweed, and other plants. The ivy-clad trees provide an interesting background to the painting.

Stage 1

For this demonstration, I will discuss only a section of my full painting (reproduced on pages 22–23). After outlining the various leaf and flower shapes in pencil, I begin working on the daffodil and narcissus heads, using a pale lemon wash. I let the first coat soak into the paper before applying the next one and in this way gradually build the color, using a no. 3 brush. These flower heads are the most delicate area in the painting, so I am careful not to put on too much paint at any one time.

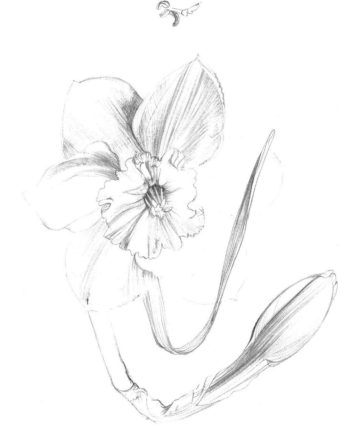

Stage 1 (detail)

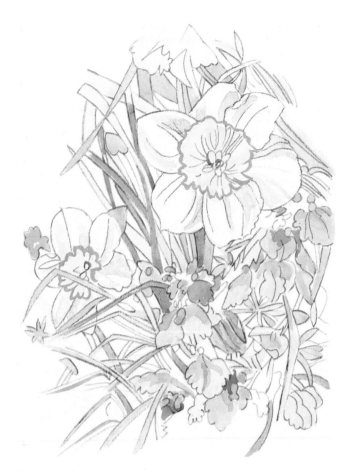

Stage 2 (detail)

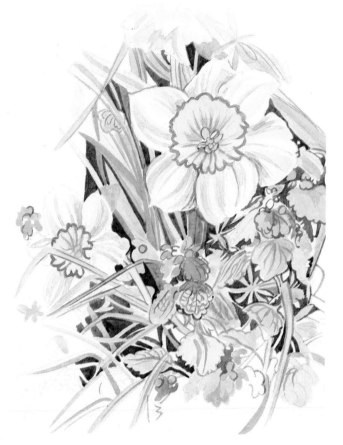

Stage 3 (detail)

Stage 2

I continue working on the flower heads, blending in the subtle shades of yellow from different combinations of lemon and cadmium yellow, using a no. 1 brush. With a finer brush I then paint the stigma and stamens in pale green. The area around the stigma is painted light brown.

Stage 3

Now I work into the leaves and red dead-nettles; as with the flower heads, I build the color gradually. For the leaves, I use mixtures of Hooker's green, leaf green, and viridian. On several leaves I add touches of turquoise. This is no more difficult than painting the flower heads.

At this stage I also fill in the spaces between the plant forms, using a dark green mixture of viridian and black. Then I gradually strengthen the color of all areas with a fine brush.

Stage 4 – the finished detail (page 21)

For the final touches, I use a finer brush and thicker paint. I strengthen the area between the plants and leaves, and then concentrate on the intricate detail. Sometimes, as in the case of the red dead-nettle, with its complicated vein structure, it is worth making preliminary sketches.

Stage 4 – the detail of the foreground which I have repainted from the original painting with fine brushwork for details and the edging. See the following pages for the complete painting

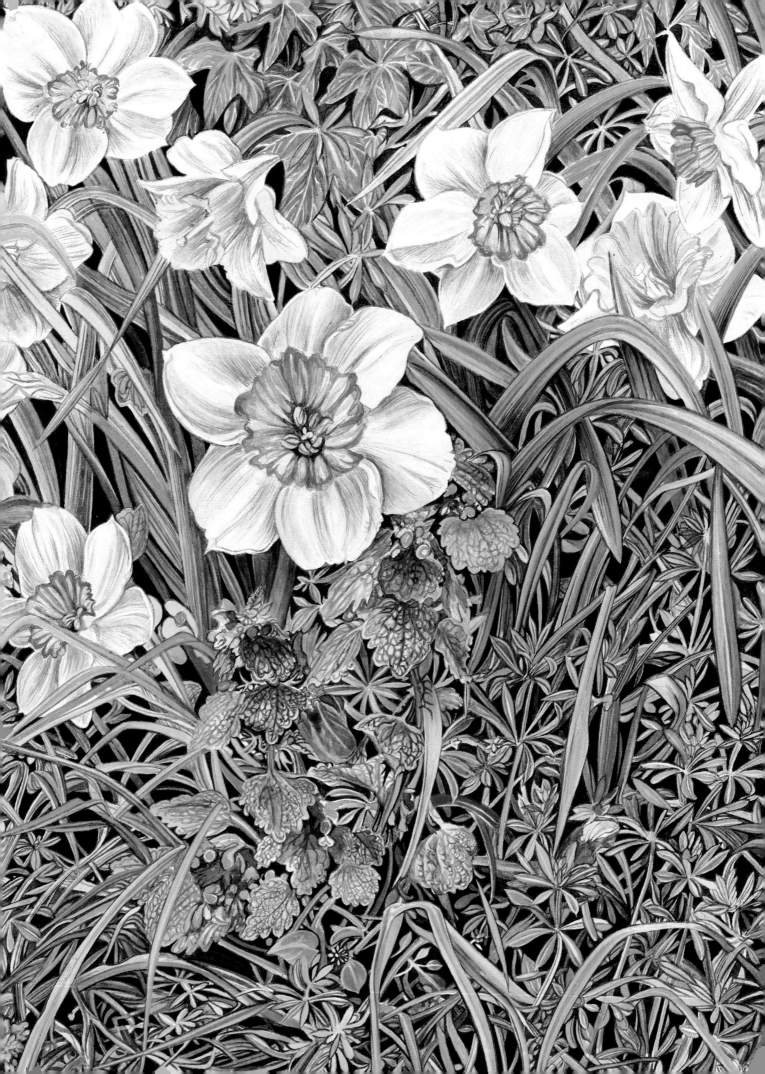

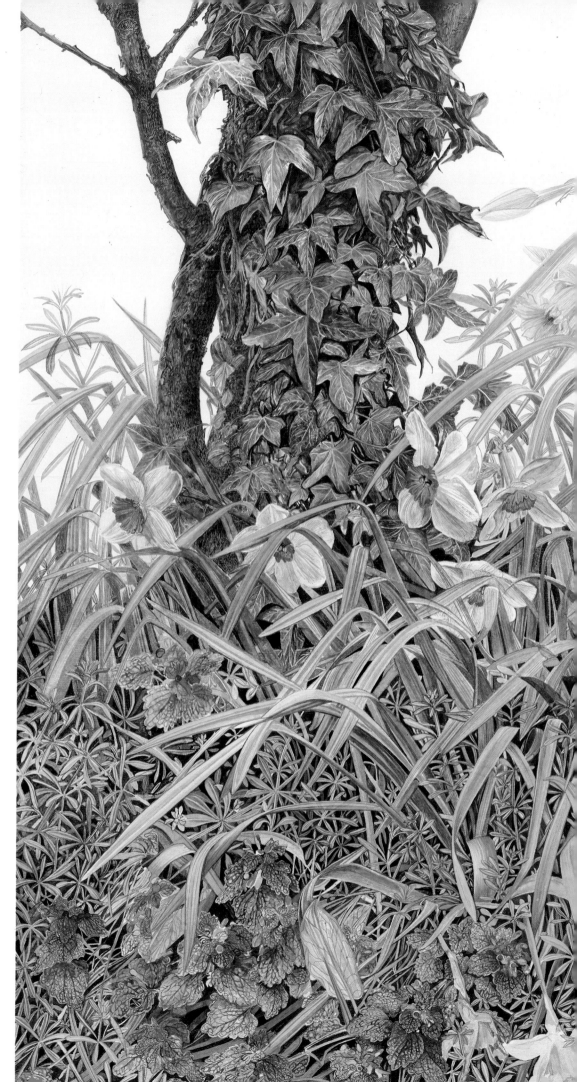

'Spring promise':
the complete painting

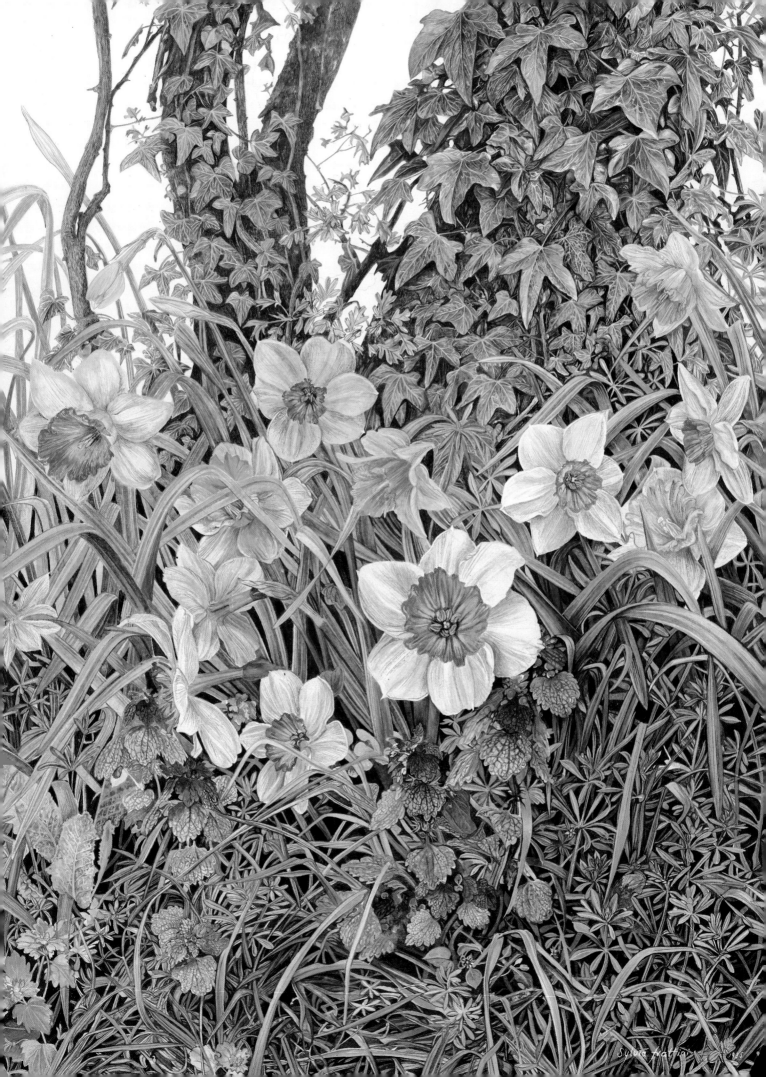

Past and present

Size: 6¼ × 8¾ inches (160 × 220mm)
Paper: Ingres Fabriano 90lb. (160gsm)
Brushes: sable nos. 1, 3

On a very cold day in January I discovered these withered ferns in my local woods. I thought they made an interesting subject in themselves and also provided a strong contrast to the mass of snow around them.

Although I did not make any sketches immediately, I realized I had an ideal winter subject, so I took many photographs, using varying shutter speeds and settings. I purposely avoided using filters as I wanted the blues and grays to complement the autumnal tones of the ferns.

It is rare to find a subject already complete enough in itself to make an interesting painting. This is the nearest I have come to using a single shot – I only had to redesign the elements very slightly.

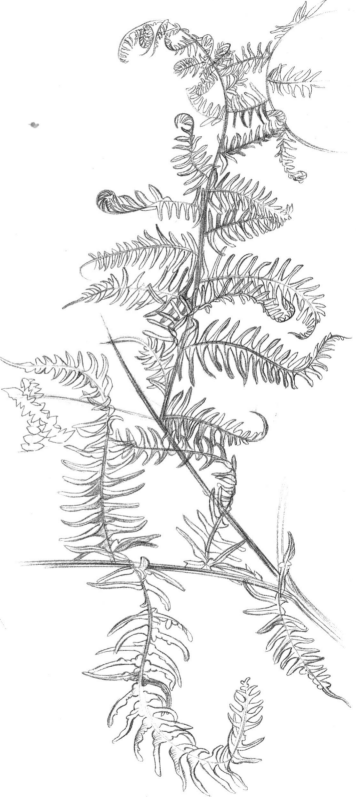

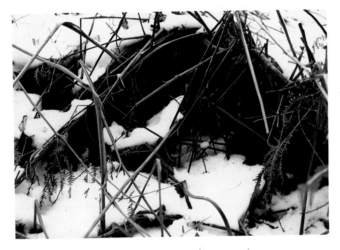

Stage 1

I block in the main areas of color, covering the entire paper. Then, working on a wet surface, I lay in light to dark washes, using a no. 3 brush and mixtures of white and Prussian blue.

 Because it will be difficult later to make any alterations in the area covered by the snow, I complete all of the ground before proceeding to the ferns. I then sketch in the main fern stalks with a 2H pencil.

Stage 2

Using my 2H pencil with very light pressure, I sketch in the intricate pattern of the ferns on top of the snow. Then I look at the drawing carefully and make any necessary adjustments before applying any paint to the ferns. I do not move on to the next stage until I am satisfied.

Stage 3

Working from light to dark, with thicker paint and a no. 1 brush, I now begin to paint the delicate ferns with mixtures of raw sienna, Venetian red, and orange.

Stage 1

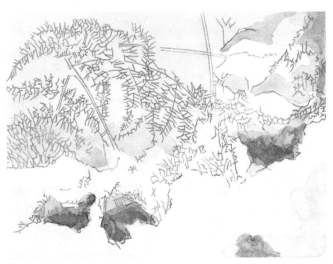

Stage 2

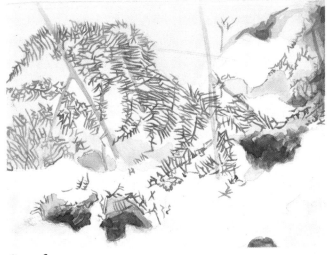

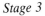

Stage 3

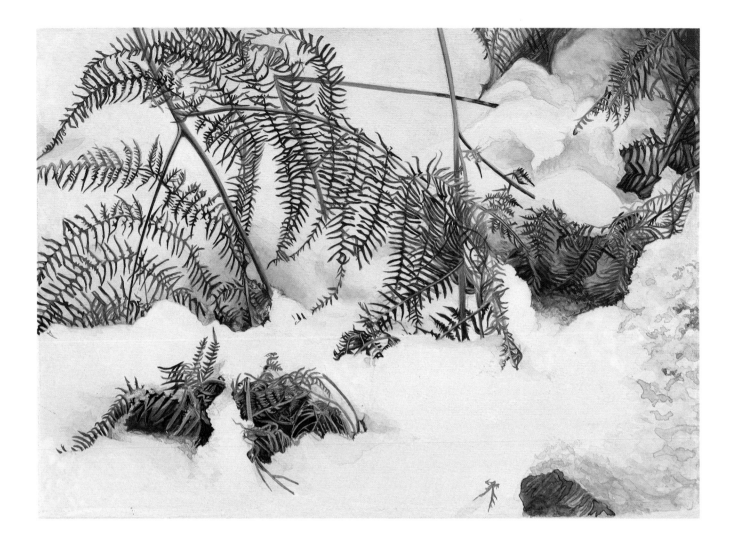

Stage 4 – the finished painting

With a fine brush I strengthen the color and continue working into the ferns until I have achieved the detail I want. For the most intricate parts I use a no. 1 brush, one which is almost worn out, for a brush containing only two or three hairs enables me to achieve the finest of lines. Note the delicate variations of color and textural effects I have added to the snow.

Autumn poppies

Size: 6¼ × 9 inches (160 × 230mm)
Paper: Ingres Fabriano 90lb. (160gsm)
Brushes: sable nos. 0, 1, 2

I always enjoy painting flowers, particularly those which grow in the wild. With the masses of poppies that flourished in the hedgerows and fields in 1985, I had plenty of opportunity to work from life and to capture accurately the true, brilliant color of the poppy.

This painting is based on photographs (see below) taken in September from the edge of a wheatfield quite close to my home. Poppies are difficult to photograph well because they are so delicate that they are never still. Where I live I am lucky enough, however, to be able to paint from the flowers themselves right up to the end of October. What appeals to me most is the striking contrast of the petals of the poppies against the rich, dark centers.

In composing the painting, the placement of the flowers is vitally important, and I have tried several positions of the heads before finding the most effective grouping. Finally, to balance the picture, I have included small daisies and long strands of wheat, which offset the poppies.

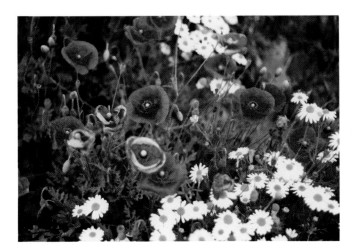

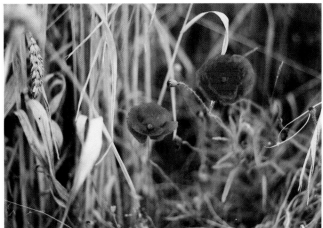

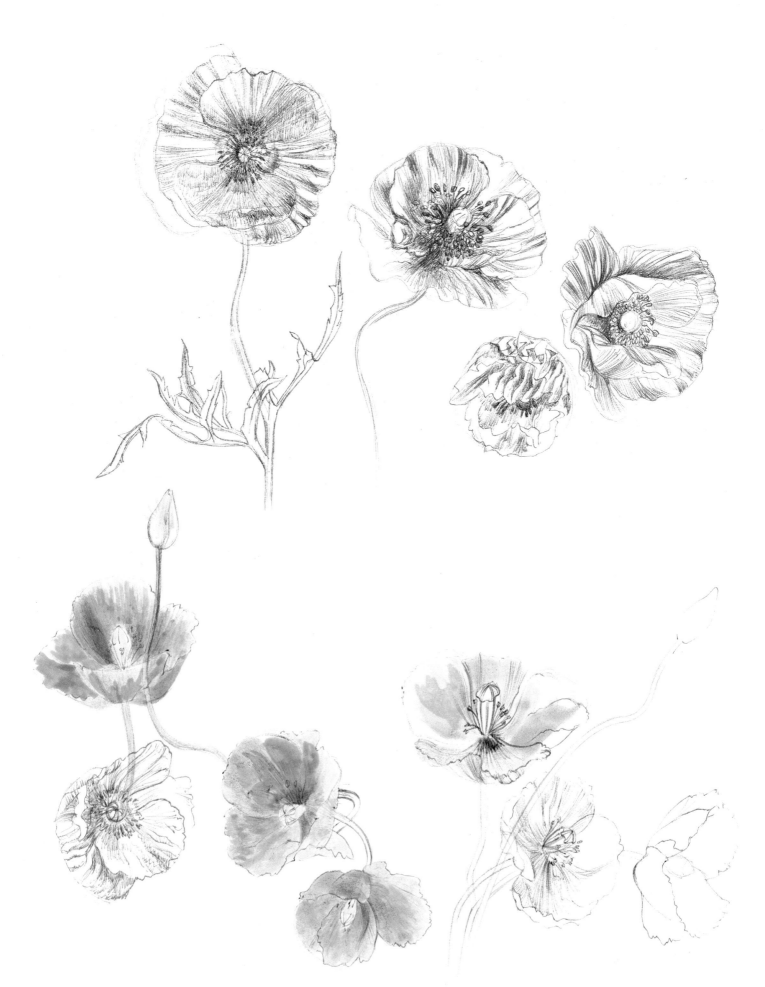

Sketch of poppies from photographs

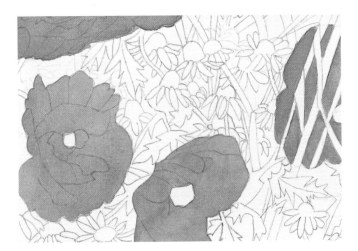

Stage 1 (detail)

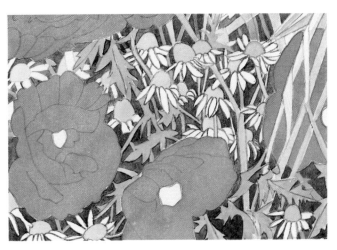

Stage 2 (detail)

Stage 1

Having outlined all the poppies and other plant forms lightly in pencil, I work into the poppy heads with a basic wash of orange, using a no. 2 brush.

Stage 2

I now fill in the background using a no. 1 brush and burnt umber. I select a pale yellow wash for the daisy heads and fill in the daisy petals with opaque white. The color of the daisies contrasts well with the poppies. For the leaves, I choose a light mixture of turquoise and Hooker's green. The wheat stalks then receive a very pale wash of yellow ochre.

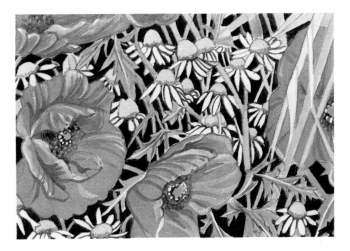

Stage 3 (detail)

Stage 3

Color mixing is important here. I try to create the soft appearance of poppies by gradually darkening the tones of orange – making sure there are no hard edges – and highlighting some of the petals in white in between the orange washes. With my finest brush I detail the petal veins, and then work into the center of the flowers with touches of purple and black, trying not to darken the centers too much. With the tip of my brush, I emphasize some of the stamens. Then, gradually building up the washes, I work into the poppy leaves, wheat, and flower stalks, and deepen the background area.

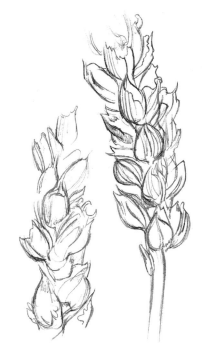

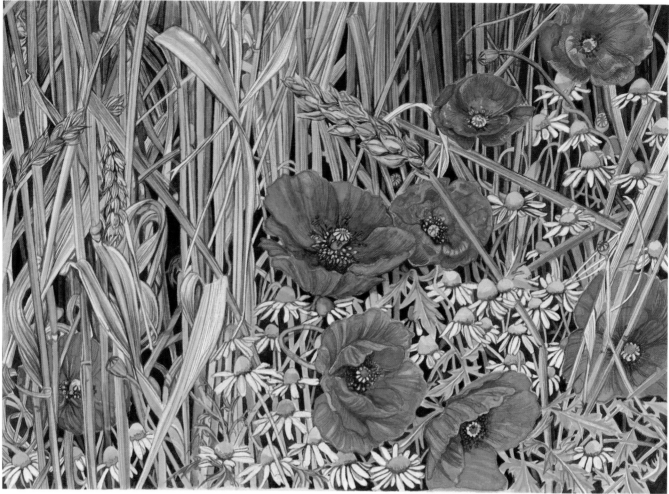

Stage 4 – the finished painting

Stage 4 – the finished painting

I continue working into the plant forms with the tip of a no. 0 brush. Then I paint very thin lines on the wheat to create a realistic texture. I also highlight some of the daisy petals with more opaque white.

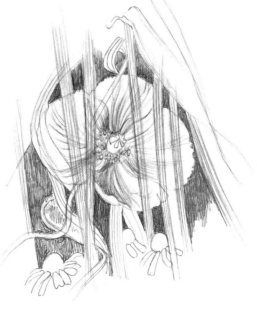

Studies of flower structures

Curious

Size: 8¾ × 8¾ inches (222 × 222mm)
Paper: Ingres Fabriano 90lb. (160gsm)
Brushes: sable nos. 0, 1, 3, 5

Stone walls can be a fascinating subject to paint. I have always been intrigued by the weathered, irregular outlines of the stones, for they contain a surprisingly wide range of textures and colors. They provide the cows in the photograph and the sheep in the picture (as well as myself) with an endless source of curiosity.

This painting began when I found an attractive, well-weathered wall supporting a flourishing growth of lichen and moss, on a wet afternoon in late spring. At the time I made only rough notes and sketches from the car, but I took many photographs to capture the rich colors, which were enhanced by the rain.

Overview of the work

In composing the painting, there are four areas to consider: the wall, middle ground, background, and sky. The wall offers the greatest challenge – that of capturing those rich colors and textures. The sharp shadows and varying outlines also provide plenty of opportunity to experiment with different techniques.

In the middle ground I decide to include the sheep, which seem to me an integral part of the Cumbrian landscape. Their entangled coats also add to the painting's interest.

For the background, I want a pleasant, peaceful scene, which I find in the nearby countryside. I keep the sky quiet and simple as a contrast to the other, detailed work.

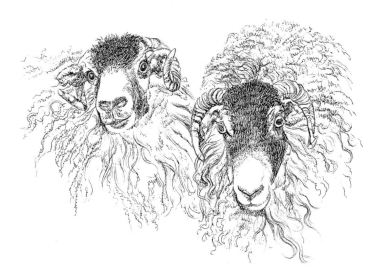

Study of Cumbrian sheep

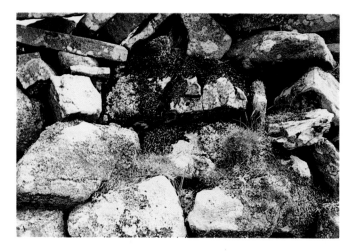

Photographs of 'an attractive, well-weathered wall, supporting a flourishing growth of lichen and moss'

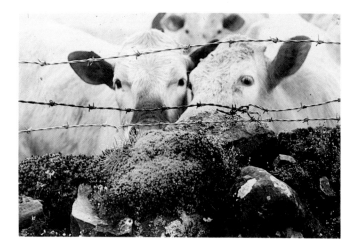

The inquisitive cows I photographed become 'curious' sheep in the painting

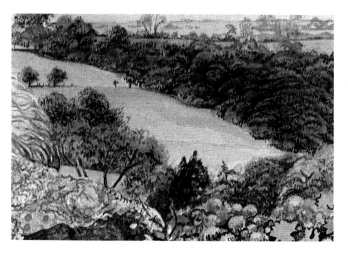

A black and white detail of the top right portion of the picture to delineate the main area of the painting – 'a pleasant, peaceful background'

Linear drawing of stone wall with pattern of lichen

Stage 1 (detail)

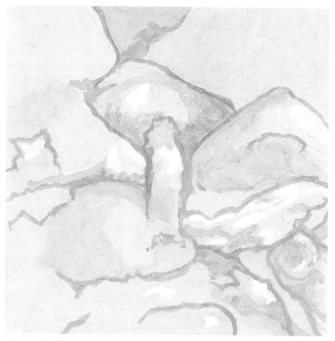

Stage 2 (detail)

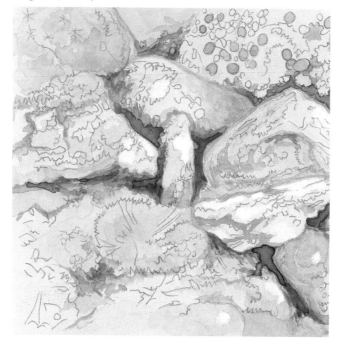

Stage 3 (detail)

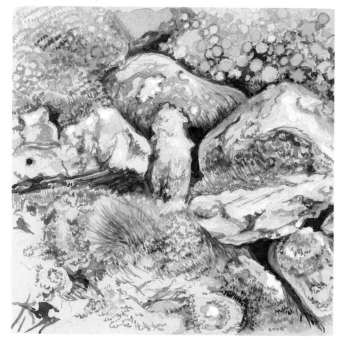

Stage 4 (detail)

Stage 1

Initially I make a fine pencil drawing outlining the stones. I then paint over these lines with a neutral color – a light mixture of cobalt blue and gray – using a no. 5 sable brush.

Stage 2

Keeping the paint thin, I try to capture the shape and color of the stones, working from light to dark. Again I use mixtures of cobalt blue and gray, but this time with a no. 3 brush. By painting wet into wet, I am able to create softer edges and model the stones more easily. I allow the paint to produce its own patterns as it dries. I then add some highlights with opaque white.

Stage 3

Now I introduce the various plant structures and stone textures. After sketching these lightly in pencil, I progress from light to darker tones, still keeping the paint thin. For the moss and lichen, I use yellow ochre, Hooker's green, and lemon yellow, as well as a maroon mixture. For the stone textures, I continue to use a mixture of cobalt blue and gray. I also fill in the shadows between the stones with dark gray. Throughout this stage I use a no. 1 brush.

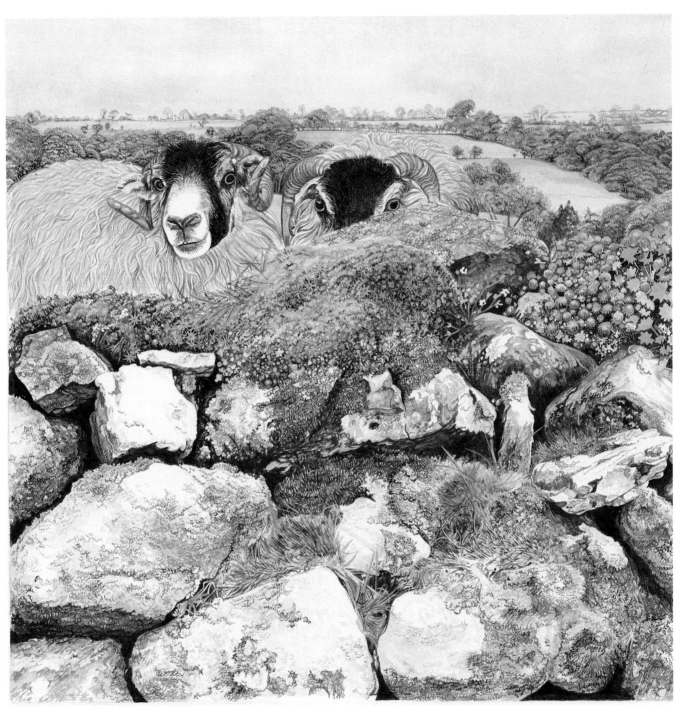

Stage 5 – the finished painting

Stage 4

Here I introduce deeper tones into the stones and shadow areas. To emphasize the stone textures, I employ the drybrush technique and, to suggest more depth between the stones, use a very dark brown. I strengthen the color throughout with thicker paint, using a fine brush. Then, with the tip of the brush, I work very carefully into the plant structures and stones.

Stage 5 – the finished painting

Using a worn no. 1 brush, I continue working into the painting. The decision of when to stop and call the painting complete has to do with how much detail I want. At first glance all the detail may appear complicated and difficult to achieve. What is needed, however, is primarily care and patience. As long as I take one step at a time and pay particular attention to the delicate structures on the wall, the total effect can be successfully produced.

You will notice that, in the drawing of the sheep, I have used a fine-tipped brush to suggest the texture of the fleece; also that the distant greens are softer in hue and tone than the foreground plants.

Woodland in springtime

Size: 9¼ × 15¾ inches (210 × 380mm)
Paper: Ingres Fabriano 90lb. (160gsm)
Brushes: sable nos. 00, 0, 1, 5

It is always a joy to observe a woodland in its various aspects, particularly with the changing seasons. Indeed, in order to portray successfully the individual characteristics of the trees, it is vitally important to sketch them constantly, at all times of year, using a sketchbook to record your observations.

Each season has its special beauty, but I find that in the spring the primroses growing in abundance under the beeches not only make a beautiful sight but provide plenty of interest for the artist. The beech trees themselves are just beginning to show a hint of green color, although most of the thin, pointed beech buds have not yet broken out into leaf.

With this scene, I am initially attracted to the structure of the tree roots. I make quick sketches and take photographs to try to capture their patterns and movement. In the end it is the camera, as so often, that gives me the idea of painting the whole scene. While I am concentrating on the exposed tree roots, I ignore the glorious mosaic of varying tones in the background between the trees. It is not until I see the photographs that I realize what a wealth of information I have for re-creating a woodland scene in spring.

Overview of the work

The background is the most demanding area to paint. It is difficult to render and combine the soft, blurred shapes of the clouds in the sky, the varying hues in between the trees, and at the same time give a feeling of the soft atmosphere of spring.

I begin by wetting the paper and merging the colors wet into wet. In doing this I gradually build the tones with light washes, taking care not to strengthen them too much too quickly. I repeat this over and over until I achieve the effect I want, with the cloud shapes on the right forming a striking patch of color (see page 41).

In contrast, the middle and foreground areas call for a more detailed approach, for which I use the point of a fine brush and thicker paint. In trying to capture the freshness of the primroses I use a minimum of detail and subtle variations of color. Initially I apply a light wash of lemon for the primroses. Remember, it is always easier to paint the most delicate areas first and then work the darker colors around these parts. Indeed, light colors are difficult to paint over a dark ground.

As I develop this area, I draw on sketches of flowers and other plant forms from my own and other gardens. To bring the foreground closer, I add some texture to the rocks, again with a fine brush.

For this painting I use a full palette to make the tremendous variety of colors required: pale yellows and greens for the foreground, rich greens for the saplings and the ivy sprawling over the rocks; reds and browns for the dead leaves and some of the remnants of winter; and blues, browns, and delicate greens for the trees and background.

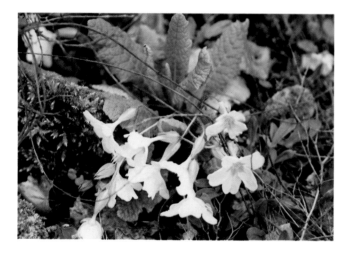

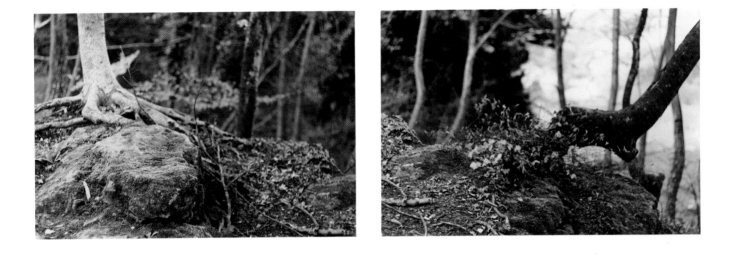

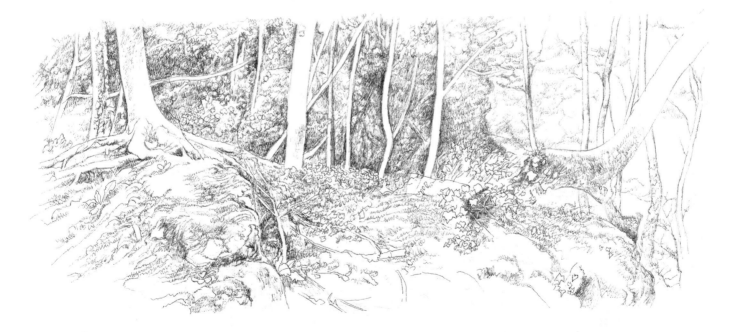

Drawing of complete composition, inspired by
photographs above but with foreground plants omitted

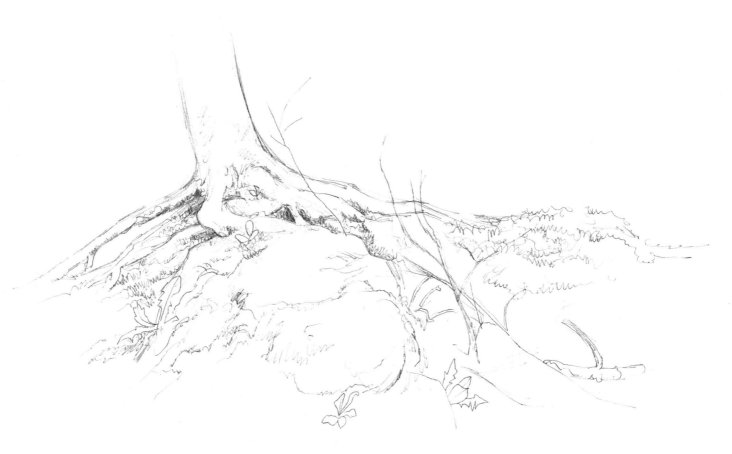

Study of tree roots

Detail of foreground with ground-tone painted in

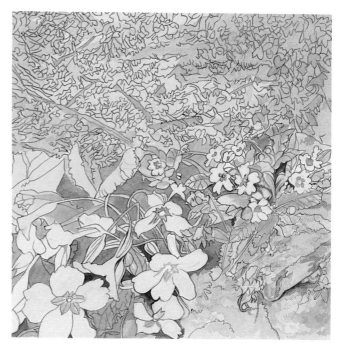

Study of foreground detail

Stage 1 (detail)

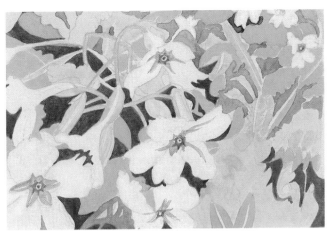

Stage 2 (detail)

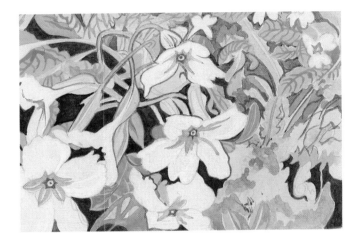

Stage 3 (detail)

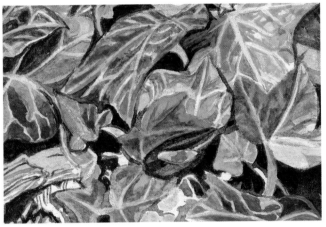

Stage 4 – detail of foreground with fine brushwork for details and edging

Stage 1

With a pencil I make a fine linear drawing of all the plant forms. Using a no. 1 brush, I fill in the primrose heads with a very pale lemon wash; then, in a similar way, I fill in the center of the flowers with a light orange wash.

Stage 2

With the same brush I block in all the remaining areas. The colors I employ are mixtures of grays and browns for the ground parts, leaf green and turquoise for the primrose leaves, and orange for the autumn leaves. For the stems, a pale pink wash seems the right choice.

Stage 3

I deepen some of the ground areas and paint shadows on the primrose petals with varying tones of lemon. With a no. 1 brush I then highlight some of the petals with opaque white and gradually strengthen the color throughout. With great care I work into the veins of the primrose leaves.

Stage 4, and the finished painting (pages 40–41)

I continue working into the painting with a no. 00 brush until I achieve the effect I want. My aim is to bring out the general contrast of tones in the woodland area rather than to concentrate on detail. I try to keep the edges soft, except where the tree trunks need to stand out. I also keep the sky pattern soft by painting wet into wet.

If you look at the finished painting, you will understand how difficult this subject is to paint. The main problem is that, as there are many areas of interest in the composition, it is hard to keep the whole scene in the mind's eye while concentrating on one particular area. In fact, on several occasions during the course of the work, I put the painting to one side and studied it carefully for a few days before proceeding to the next stage.

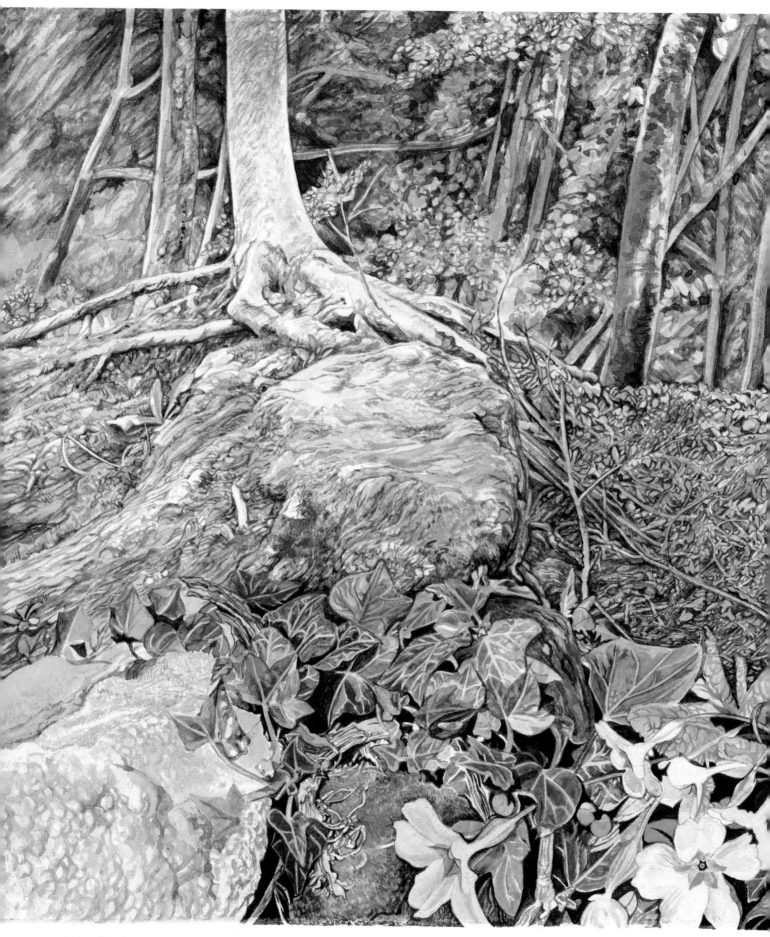

'Woodland in springtime' – *the complete painting*

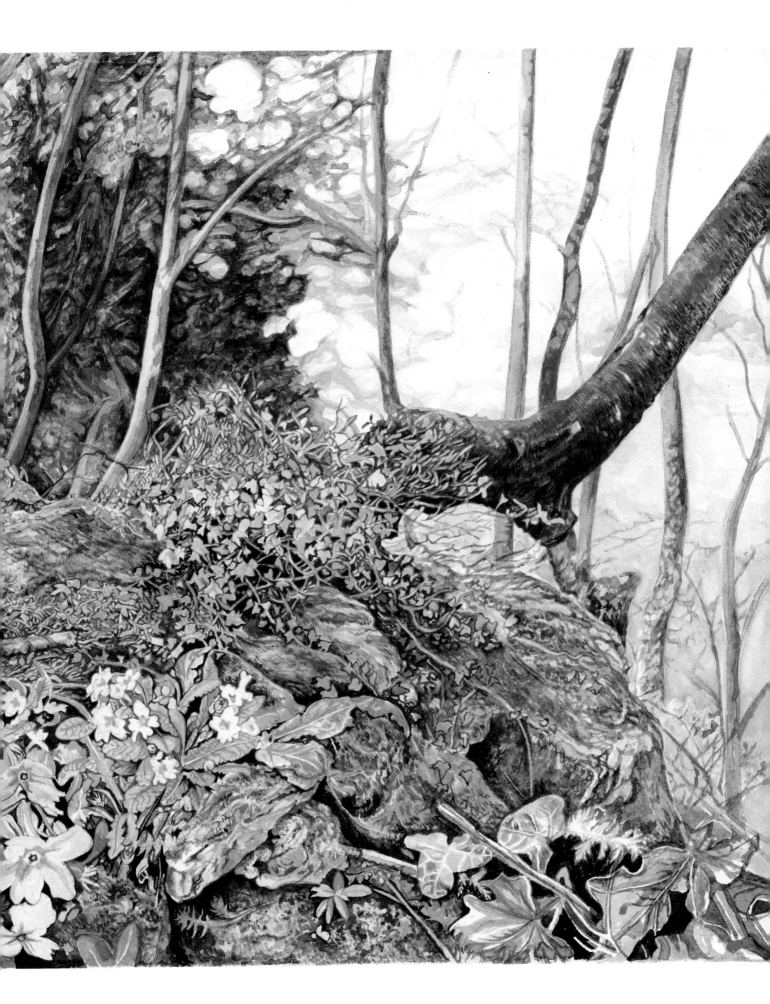

Summer shore

Size: 6¼ × 9 inches (160 × 230mm)
Paper: Ingres Fabriano 90lb. (160gsm)
Brushes: sable nos. 0, 1, 2

As a child, a visit to the seashore was always a special occasion for me. As I grew older, many of my leisure hours were spent strolling and sketching along this favorite stretch of coastline in north-west England. Whatever the season or the time of day, the seashore has never failed to interest me, with its driftwood, beautifully colored stones, variety of shells, bird skeletons, seaweed, and wild flowers.

When, in June 1985, I returned to take a fresh and closer look at my childhood seashore, I was intrigued by the wealth of detail to be found in a relatively small space. How many people, I wondered, walk these parts every day without really observing the sights underfoot? I was amazed to see goose grass struggling to survive among the pebbles – the same plant that grows in profusion in my own garden (see *Spring promise*, pages 17–23). It was, however, the pebbles, with their endless variety of shapes, colors, and textures, that made me want to paint this scene. I was also intrigued by the shells – especially when parts of them had been worn away by the sea and sand to reveal their internal structure.

With this painting I had the opportunity to paint almost the entire composition from life, for, after my preliminary sketching and photographing, I collected the more interesting objects and brought them to my studio.

Sketch from photograph

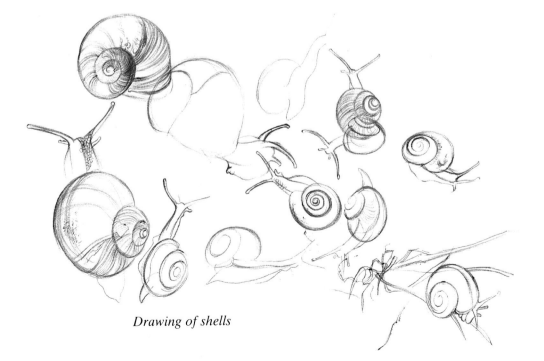

Drawing of shells

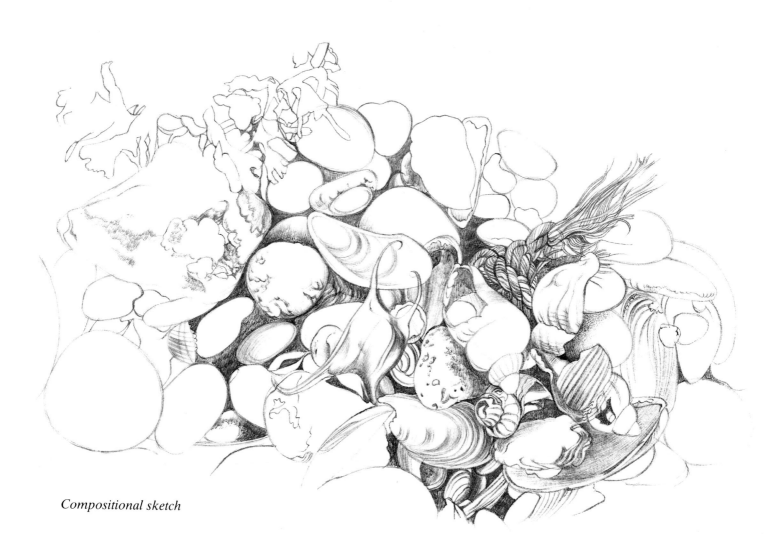

Compositional sketch

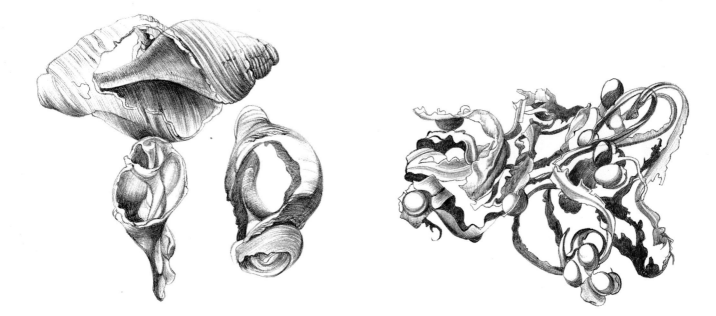

Structure of shells

Study of seaweed

44

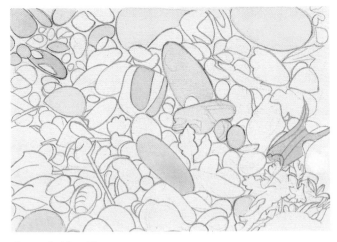

Stage 1 (detail)

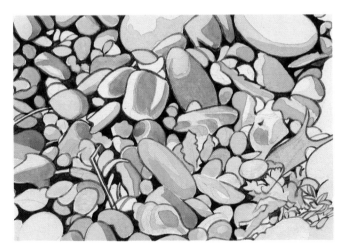

Stage 2 (detail)

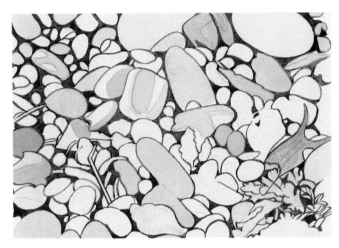

Stage 3 (detail)

Stage 1

I make a pencil drawing outlining all the shapes: pebbles, shells, and other objects. With light washes and a no. 2 brush, I then fill in some of the larger pebbles.

Stage 2

Using the same brush but stronger washes, I block in more of the shapes. Then, using a no. 1 brush, I fill in the area between the shapes with a dark gray mixture.

Stage 3

Here I block in the remaining shapes with even stronger colors and deepen the color of some of the areas between the shapes to create greater depth. With the deeper tone used on the shape itself, I fill in some of the main shadow areas.

Stage 4 – the finished painting (pages 46–47)

With my finest brush, I continue to work into all the shapes until I am satisfied with the effect. I give particular attention at this stage to the seaweed and the shells. For the pebble textures I use a stippling technique.

Finally, to give my picture strength and unity, I include some sea bindweed in the foreground. Its trailing stems, mass of heart-shaped leaves, and conspicuous trumpet-like flowers complement the rest of the scene. I am lucky to be able to use a similar plant growing in a hedge near my home as a reference.

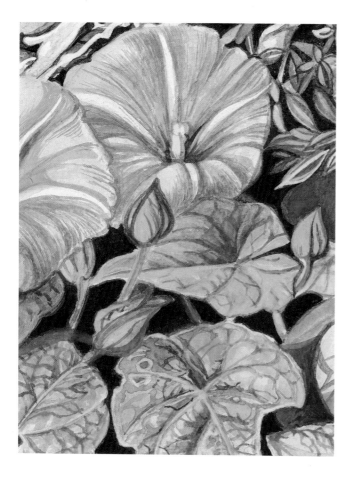

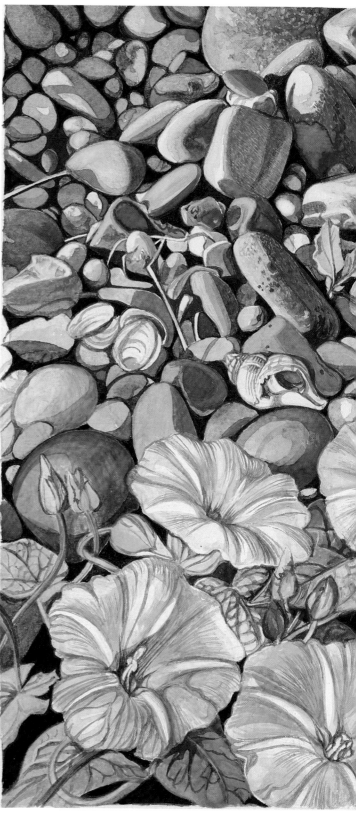

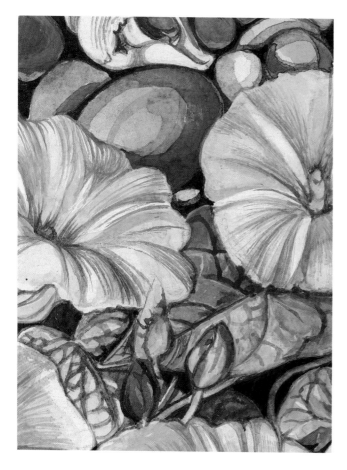

Stage 4– the finished painting with, (left) two enlarged details.

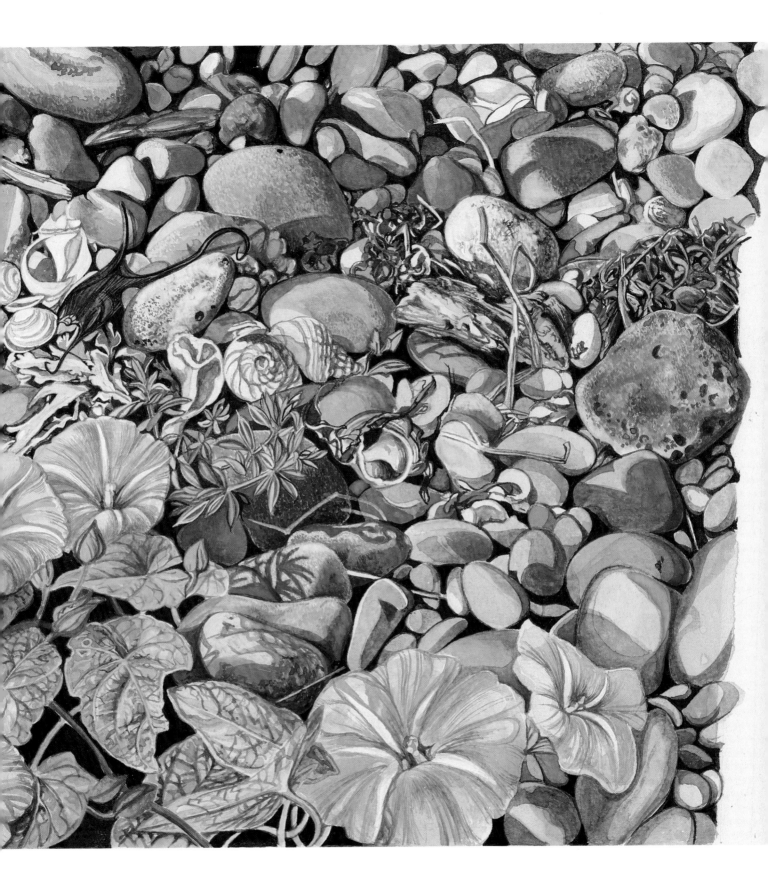

Springtime miniature landscape

Size: 8½ × 8½ inches (220 × 220mm)
Paper: Ingres Fabriano 90lb. (160gsm)
Brushes: sable nos. 0, 1, 2, 3, and 1-inch Daler

This painting is based on sketches done up in the hills and on photographs taken during a showery afternoon in May. For me, the weathered stone wall – with its rich colors, emphasized by the rain, and interesting shapes and textures – sets up a challenge. I am interested in using the wall, which has a flourishing growth of moss and lichen, as a focal point in the picture. To extend the area of interest, I include additional stones, plants, and flowers, which create the impression of a landscape in miniature.

You might compare this scene with my painting *Curious* (page 35). In a similar way, the scene breaks down into three principal sections: the sky, the wall, and the foreground.

I keep the sky cool and simple, in contrast to the detailed wall and entangled undergrowth. The stone wall, with its angular outlines and sharp shadows, gives me an opportunity to experiment with a variety of techniques. The foreground then provides an interesting mass of color. If you look closely, you will notice the bright yellow of the dandelion and the daisy just beginning to open. At this time of year many other wild flowers are also beginning to appear. The nettles and grass give me the chance to paint varying patterns of green.

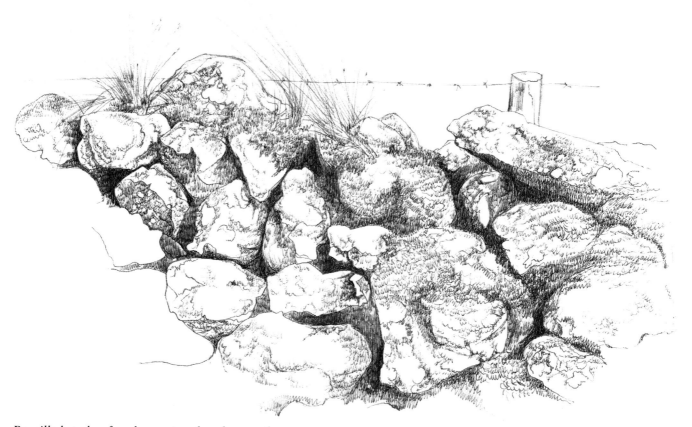

Pencilled study of rocks, post and undergrowth.

Stage 1

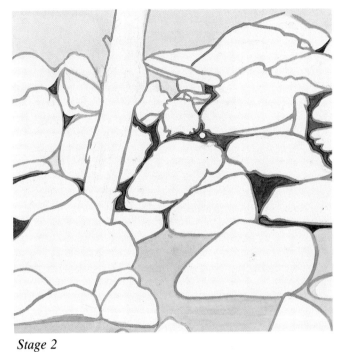

Stage 2

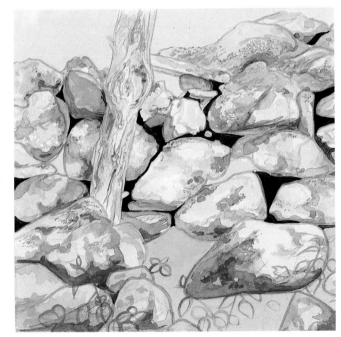

Stage 3

Stage 1

I make a linear pencil drawing of the stone shapes and wooden post, and then paint over the lines with a neutral color, suitable to the subject-matter. I choose a blue-gray mixture and a no. 2 brush.

Stage 2

I put enough color on my palette for the sky and ground areas. For the sky, I choose a pale blue mixture, which includes light red and violet. To cover the ground area I use a soft, fresh spring green. Working from top to bottom, I then fill in certain areas. In doing this I slightly raise my drawing board to allow the paint to run downward – a useful technique for flat areas. If a second coat of paint is necessary, I allow the paint to dry completely before proceeding. Finally, I fill in the deepest shadows between the stones, using a gray mixture.

Stage 3

Keeping the paint thin, I try to capture the shape and color of the post and stones. When the paint is dry, I add mixtures of sepia, yellow ochre, Hooker's green, and lemon yellow, and use a drybrush technique to suggest the moss and lichen. At this stage I begin to differentiate the textures of wood, stone, and natural growth. Using drybrush again for the wooden post and stones helps to suggest the roughness of the surface. I also indicate some of the larger plants in the foreground, such as brambles and nettles.

I leave some areas of paper for highlights, as on the stones. But, because I am working on a cream-colored paper, I add opaque white for true highlights.

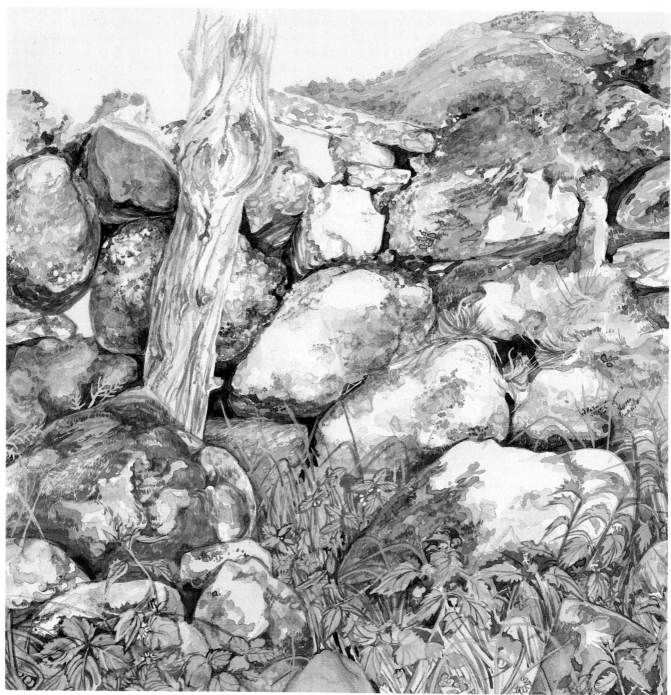

Stage 4

Stage 4

Here I introduce deeper tones of color into the stones and shadow areas, particularly between the stones. For the darkest shadows, I use a very dark brown, as this results in a much deeper shadow than black.

Now it is time to work into the varying textures of the wooden post, stones and moss. Until I am satisfied with these I do not attempt the undergrowth.

Finally, after strengthening the color throughout where necessary, I begin to consider the undergrowth, taking the largest plants first. I outline these in a medium shade of green and fill in various leaf shapes in a variety of greens and lemon yellow. With thicker paint, I fill in the grass, ferns, and other leaf shapes. The painting could be considered finished at any time now, but I am not yet satisfied.

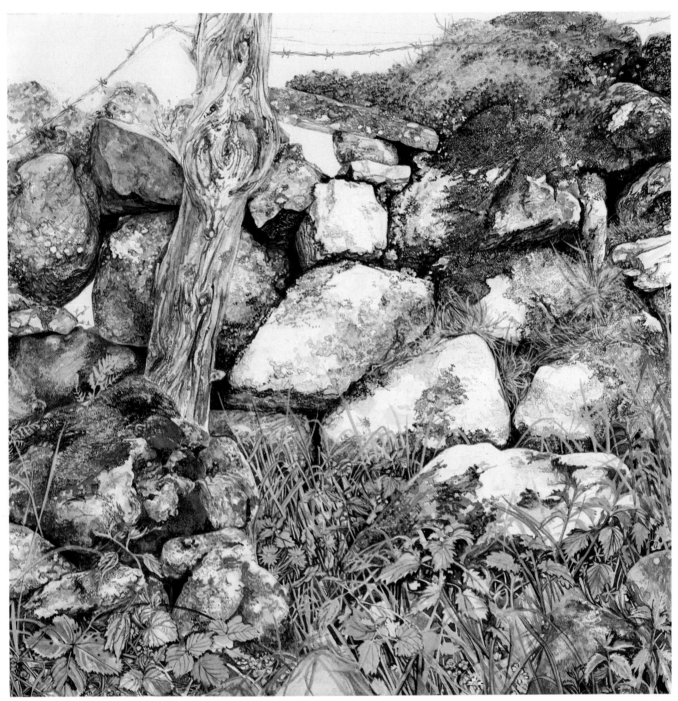

Stage 5 – the finished painting

Stage 5 – the finished painting

As with my other paintings, this final stage may appear complicated and difficult to achieve. But, once again, it is a question of taking one step at a time and paying special attention to the delicate plant structures on the wall and to the stone textures.

I continue to work into those surfaces and plants, using a fine but well-worn brush for the detail. I take special care with the lichen on the wall, working light to dark with thick paint. At the last moment I add the barbed wire to give the whole painting an extra horizontal interest.

James Lester
Painting with freedom and control

Anyone who has ever walked down a country lane in spring or summer cannot fail to have been thrilled by the profusion of plants and flowers that grow, climb, twist, intertwine, and overflow into every inch of the banks and hedgerows. In this prolific growth there are endless subjects for the painter. But there are also the brilliant colors of autumn and the soft grays and browns of winter. These same hedges and banks provide subject-matter all year round.

When you look at a group of wild flowers growing in a hedgerow and select from that group certain elements to compose a painting, it is wonderful to think that, in making this choice, you are making your subject unique. In the majority of landscape paintings there is usually some part that has a man-made permanence, whether it be a house, church, windmill, fence post, or stone wall. This part, of course, has already been seen and considered by many people, some artistic and some not. But your own selected group of flowers and plants exists solely as it strikes your eye on one particular occasion. It is your unique experience. One hour later, the light will have changed; one day later, perhaps the flowers will have started to die; one week later, that spot may be overgrown by a different group of plants. So, in your painting you can strive to express your feelings about an experience that is yours alone.

To capture that experience, of course, a certain competence is necessary both in drawing and in the handling of watercolor. The best way to achieve this is by constantly making drawings, notes, and watercolor sketches. Make it a habit always to carry a pencil and sketch pad – one small enough to slip into your pocket is quite sufficient – and to do quick studies wherever and whenever the opportunity arises. You will be surprised at how quickly your drawing will improve and your confidence increase.

Study for my painting Brambles, *pages 64–65*

Method

When I paint a group of plants or flowers in their own habitat, I always begin with fairly careful, detailed drawings of individual specimens. In this way I build a knowledge and understanding of each plant so that, when it comes to my finished painting, I can paint as directly and freely as possible, confident that I know the character of each leaf and flower. At the time I make the drawings I have probably not selected the actual subject for my painting at all, but I know which flowers are abundant at that time of the year, and I know which ones I am likely to use for my final painting.

Occasionally, when circumstances prevent my making drawings and notes, I take photographs to use as reference material. In general, however, my advice on the use of photographs is: 'don't!'. There are two reasons for this. First, a photograph seldom provides sufficient detail or information for a proper understanding of a subject; second, a photograph is an entity of its own and there is a great danger – especially for the less experienced painter – of simply copying the photograph, without understanding, without creating your own composition, or without making any personal statement. Use photographs as a last resort, and then only those you have taken yourself, for the express purpose of keeping a record.

It is, of course, possible to take samples back to your studio in order to make studies to finish off a painting, but nowadays most people who care about the countryside realize that many wild flowers are under threat of extinction. Picking them is not recommended. Use your discretion. Cowslips and primroses, for example, should be left alone, but I doubt if taking the odd spray of ivy will have a detrimental effect on the countryside.

Deciding on the content of your painting can be difficult. A group of flowers in a bank or hedgerow may at first glance seem overwhelmingly confusing. Be selective. It is not possible (even if it were desirable) to reproduce every hair and line on every leaf and twig that you see in front of you. Instead, select the main elements that attract you, emphasize them, and play down the aspects that are less important to your composition. Try to use plants as they grow naturally, and do not rearrange them into a 'nice' pattern. Growing plants tend to fall into a natural arrangement, infinitely more beautiful than anything the most talented flower arranger could produce.

Painting flowers in their natural environment poses a special problem for the watercolor painter. If you look at a thickly growing bankside, you immediately see that the flowers are almost always the lightest elements – they stand out like little colored stars against a dark background. To keep the fresh color of the flowers, they must be painted with clean washes of bright color which take advantage of the brilliance of the underlying white surface. This implies, however, that the rest of the painting – the plant leaves and the background – must be carefully painted up to and around each petal of every flower. The danger with this process is that any freedom or freshness of approach may be lost and the picture may become 'tight' and rather tired-looking. To overcome this, I frequently use masking fluid to isolate the clean color of flowers. It is then possible to paint everything else as freely and as broadly as I wish.

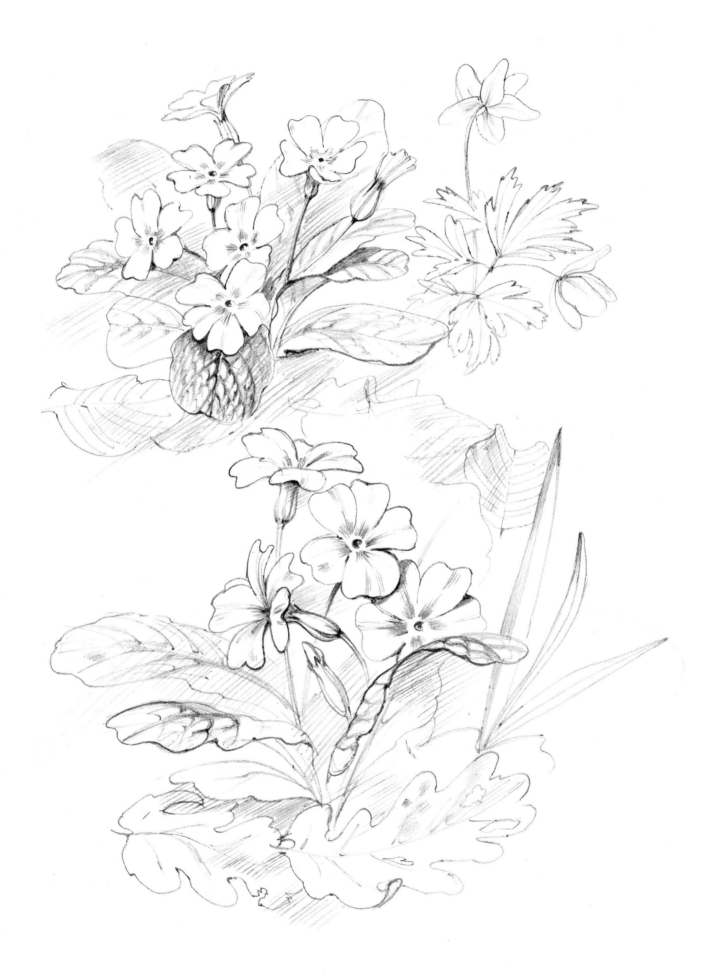

Primroses

Size: 9³/₅ × 9³/₅ inches (240 × 240mm)
Paper: Fabriano 140lb. cold-pressed (300gsm)
Brushes: sable nos. 3, 6, 10

I came across this little group of primroses growing on the edge of a wood on one of those bright spring days when the first leaves are showing signs of breaking out. In painting them I wanted to portray the soft luminosity of the pale yellow flowers against the fresh greens of spring. The brown carpet of dead leaves then hints at the past months of winter, now over.

Stage 1

I make a simple pencil drawing of the composition, but delineate the flowers with care and precision. Then, with a small brush, I cover each flower with masking fluid and let it dry. I wash the brush immediately and clear all traces of the masking fluid from it. Once the fluid dries on a brush, it becomes very difficult to remove.

Stage 2

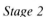

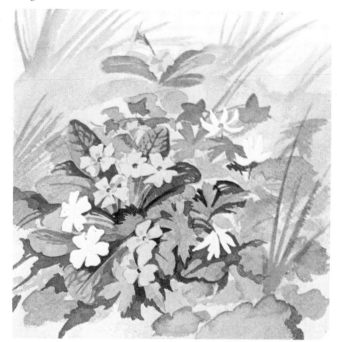

Stage 3

Stage 4

Stage 2

With a large brush, I lay a light wash of ultramarine across the top third of the picture. While this is still damp, I mix Hooker's green and yellow ochre and paint in the grass at the top of the bank. I use a medium-size brush, a no. 6 sable, and paint quite freely with simple washes of color.

Stage 3

Now I paint in the leaf shapes of the primroses and the wood anemones. Then, working lightly with a pencil, I position the other elements in the picture.

Stage 4

Over the remaining white paper, I lay a light mixture of Hooker's green and yellow ochre. As this dries, I paint the shapes of fallen leaves into it, using Vandyke brown and a little sepia. Then, mixing Vandyke brown with some ultramarine, I introduce the dark shadow areas below the leaves. At this point it is vital to establish the correct tonal balance overall and bind the various elements together.

I continue to paint other areas of foliage and, with a mixture of Hooker's green and Payne's gray, form and model the leaves. I then allow the picture to dry, gently remove the masking fluid, and, with washes of lemon yellow and aurora yellow, add color to the primroses.

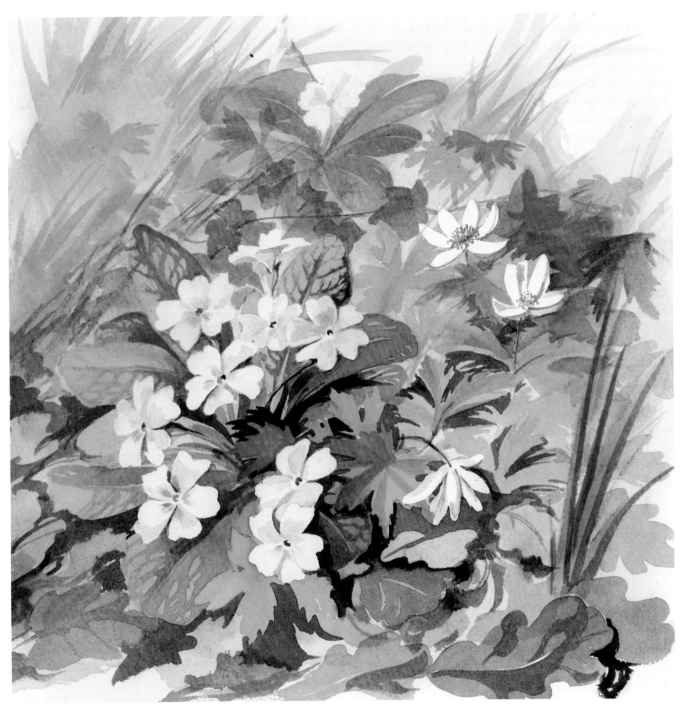

Stage 5 – the finished painting

Stage 5 – the finished painting

Using a very light wash of gray and green, I develop the form of the primroses. To obtain the rich yellow at the center of each flower, I mix aurora yellow with just a touch of scarlet lake. Next, to give shape to the wood anemones, I use simple washes of Payne's gray. I continue to clarify form and shape as necessary throughout the picture, and also paint in the rest of the grass and foliage in the background. Finally, I complete the painting by strengthening the dark shadows, which emphasize the shape of each plant.

Poppies

Size: 8 × 11 inches (209 × 290mm)
Paper: Fabriano 140lb. cold-pressed (300gsm)
Brushes: sable nos. 1, 3, 5, 6, 10

During a visit to the south-west of England, I was walking along a coastal path in Devon and found a stretch of cliff top overflowing with mayweed and poppies. The flowers were dazzlingly bright in the afternoon sun and the blue sea beyond helped to emphasize their brilliance. With the curious rock formation in the distance, it seemed to me a flower painting from which it was impossible to exclude the splendid background landscape.

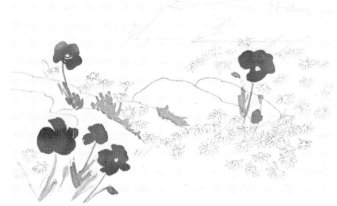
Stage 1 (detail)

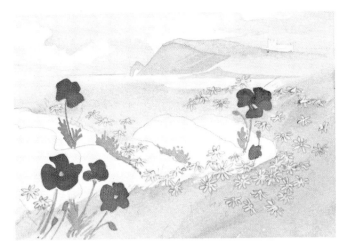
Stage 2 (detail)

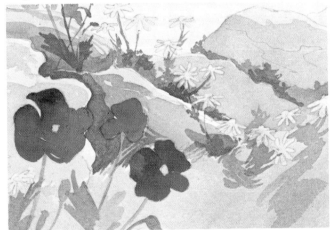
Stage 3 (detail)

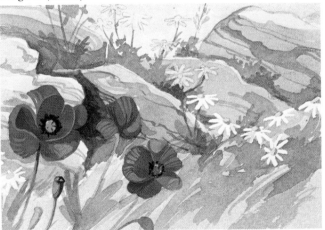
Stage 4 (detail)

Stage 1

I make a simple but precise pencil drawing of the overall composition. In particular I record the sweeping curve of the mayweed, which links the background landscape with the rocks and poppies in the left foreground. I now paint in the bright colors of the poppies.

Stage 2

With a small brush I cover every flower – poppies and mayweed – with masking fluid. I wet the paper all over and paint the sky and sea together, leaving the white clouds as clear paper. The sky is mostly Prussian blue with a touch of alizarin crimson in places to create the darker clouds, while the sea is basically Prussian blue with ultramarine flooded into it to suggest depth and currents in the water.

While everything is still wet, I lay in a wash of green, going from the cliff top right through to the foreground, covering the entire area of grass and plants. I also continue to work on the silhouetted cliffs, headland, and sky, to complete the whole background landscape in one step and thus preserve its freshness.

Stage 3

Using a medium-size brush (no. 5 or 6), I work as freely as I can without losing control of the drawing and paint in the main tonal areas of the rocks and plants. Remember, it is the character of the plant that you need to portray. You are not making a careful botanical study. At this point I also ensure that the foreground tones are balanced in relation to the distant background.

Stage 4

As I continue to develop the form and structure of the rocks, I begin to add more definition to the plants. After removing all the masking fluid, I form and shape the flowers. The poppies are painted with varied tones of scarlet lake with just a little alizarin crimson in the petal shadows. The centers of the mayweed flower are pure aurora yellow.

Stage 5 – the finished painting

I now deepen the tones in the foreground and complete the form and detail of all the flowers. I also use some of the basic greens and grays to paint around a few of the flower shapes to give greater definition and clarity.

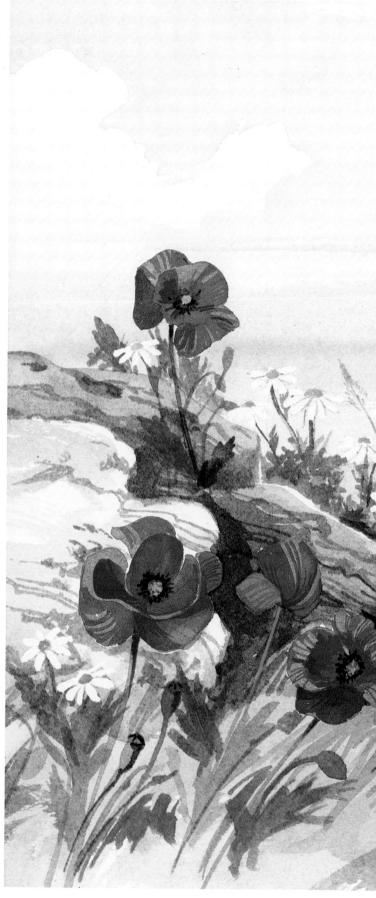

Stage 5 – the finished painting

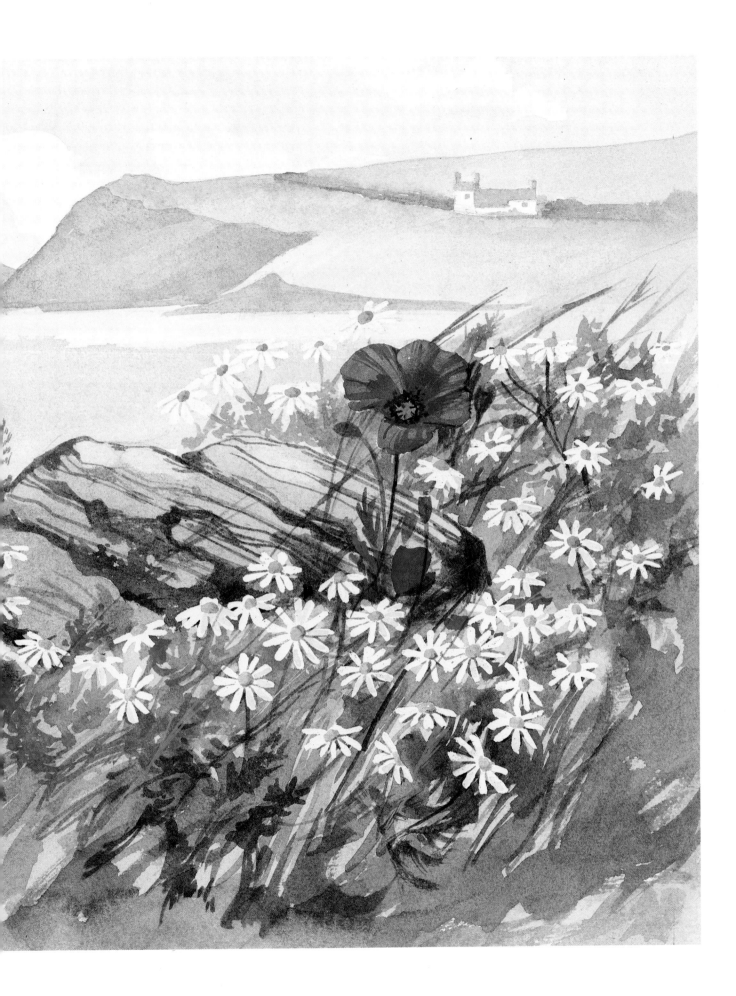

Brambles

Size: 14⅕ × 21⅖ inches (355 × 535mm)
Paper: Fabriano 140lb. cold-pressed (300gsm)
Brushes: sable nos. 3, 5, 10

For this painting I followed the same method as in *Poppies* (pages 60–63), except that here I relied heavily on drawing and studies rather than painting on the spot. I painted the background landscape on a brief visit to Pagham Harbour in Sussex, on the south coast, but I did

not have the time then to develop it. The background, however, established my color key. A few weeks earlier I had made a number of detailed studies of brambles. I took a piece of bramble back to my studio and, with this reference and my studies, completed the picture.

Rose hips

Size: 14 × 10⅕ inches (350 × 255mm)
Paper: Fabriano 140lb. cold-pressed (300gsm)
Brushes: sable nos. 3, 5, 10 or 12

In autumn the hedgerows are full of color – at times, there is so much color that it is difficult to isolate a small area. This painting represents part of a hedge where a wild rose, with its scarlet hips, mingled with the dazzling color of a field-maple bush. I noticed that the bush was constantly visited by a flock of blue tits, and it occurred to me that adding a bird would provide a focal point among the dominant pattern of leaf shapes.

Fortunately, I had recently made some bird studies. My garden is so full of trees and shrubs that it is a great attraction for a variety of birds. One winter day, eight months earlier, I found a blue tit that had died during a spell of cold weather. Although my immediate reaction was one of sadness, I used the opportunity to make some detailed drawings and studies. Now, these studies became of real use in this painting of autumn leaves.

The importance of making sketches cannot be over-emphasized. Not only is it the one sure way to improve the quality of your drawing, but it also gives you a store of reference material, which can prove invaluable.

Stage 1

Stage 1

First I wet the paper; then, with a large brush (a no. 10 or 12 sable) and using a mixture of cadmium yellow with a hint of brown madder, I lay a graded wash diagonally across it. I start from the bottom right corner and cover about two-thirds of the picture area; I then let it run into a very light wash of ultramarine at the top left. Next I lightly indicate the direction and thrust of the main stems and begin to paint the bright leaf shapes and scarlet rose hips.

Stage 2

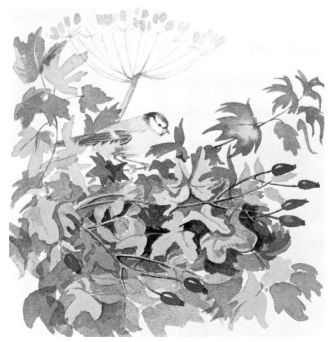

Stage 3

Stage 2

With a minimum of drawing I now indicate the bird and continue painting the foliage, arranging leaves of a unified tone around the line of each individual stem. I paint the dried cow parsley (or cow parsnip) in the background, but keep it light enough in tone not to dominate. Most of the leaves are painted with different mixtures of cadmium yellow and yellow ochre or brown madder, with an occasional touch of Hooker's green.

Stage 3

Using dark tones of Vandyke brown, brown madder, and Payne's gray, I paint the areas of shadow behind the bright leaves and hips. By varying the intensity of these shadows, I try to suggest the dark interior of the bush. I also give some more definition to the bird and start to refine the leaves.

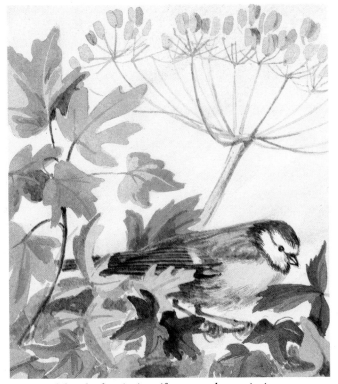

Detail of finished painting (for complete painting, see page 68)

Stage 4 – the finished painting (page 68)

I now develop the form and details of the leaves and the rose hips, and also strengthen the shadows. I add definition to the stems to ensure that they provide the main directional thrust of the composition. Then I provide the minimum detail necessary to give form to the cow parsley. Lastly, to complete the picture, I finalize the detail of the bird.

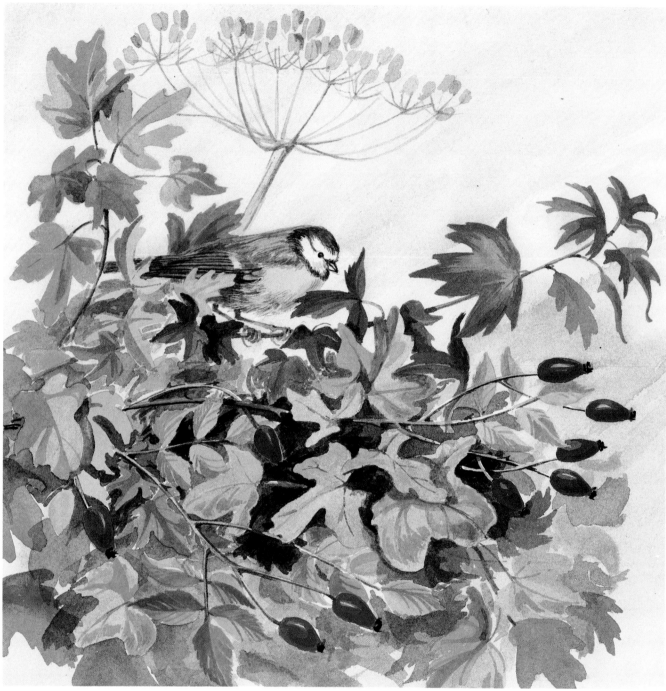

Stage 4 – the finished painting

Buttercups

Size: 9⅗ inches × 9⅗ inches (240 × 240mm)
Paper: Arches 140lb. cold-pressed (300gsm)
Brushes: sable nos. 1, 5, 6, 10

There is no need to take trips or carefully planned excursions to find subject-matter for painting – the clump of buttercups in this painting was growing in the long grass just at the end of my own garden. Each flower was wide open; they were all leaning eagerly toward the hot June sun and seemed to have the warmth of summer in them. My aim was to catch something of their movement and of the thrusting, rapid growth that overwhelms the English countryside in June.

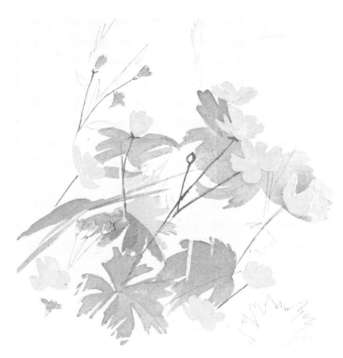

Stage 1

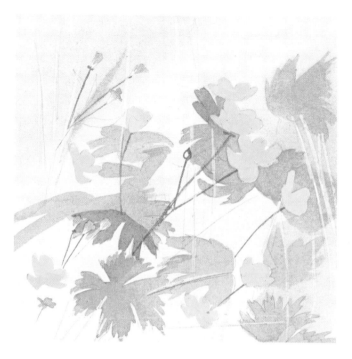

Stage 2

Stage 1

I lightly draw in pencil the main features of the composition and then use Winsor yellow for the buttercup flowers and Hooker's green with yellow ochre for the leaves, painting in broadly some of the main areas. For the small touches of color on the other little flowers, I use permanent rose. At this stage I am only beginning the painting, so when I notice how a fly keeps returning to one particular leaf, I decide to include it.

Stage 2

Carefully I cover the bright areas of the flowers with masking fluid. I also use masking fluid to paint freely some grass stems in the background. Next I wet the paper and quickly lay a light wash of ultramarine across the top left corner, immediately followed by a light wash of aurora yellow over the rest of the sky and then a further light wash of ultramarine down the right side. The area of yellow helps to create a feeling of bright sunlight. I now start to paint in more leaves.

Stage 3

While the paper is still wet, I lay a wash of Hooker's green across the bottom half of the picture. Then, as the paper dries, I use varying proportions of Hooker's green and yellow ochre to create a variety of greens as I develop the buttercup leaves and grass. For this I use a no. 6 sable and paint as broadly and as confidently as I dare, although still retaining the character of each leaf. Then, with a slightly finer brush and using a mixture of Hooker's green and indigo, I start broadly laying in the shadows. My aim at this point is to bind the elements together and establish the correct overall tonal balance. Lastly, using Vandyke brown, I begin to indicate the fly.

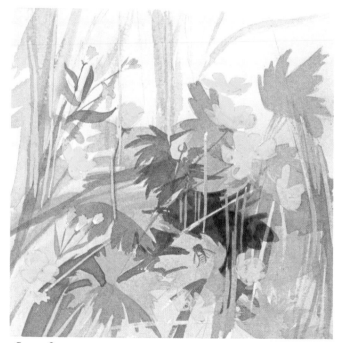

Stage 3

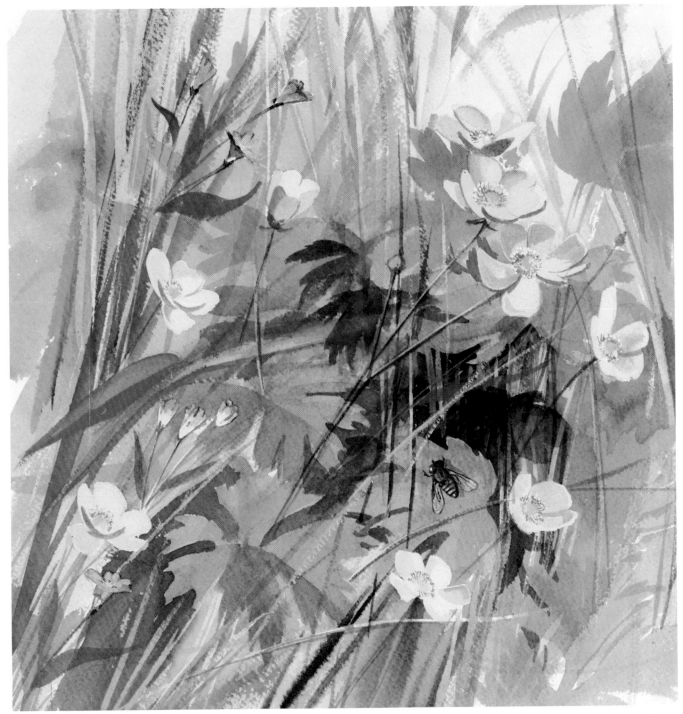

Stage 4 – the finished painting

Stage 4 – the finished painting

Gently I remove the masking fluid. Then, using yellow ochre with an occasional touch of green, I develop the form and shape of each flower. The stamens at the center of the buttercups are put in carefully with a fine sable. In the areas where masking fluid once covered the grass stems, I now use a light wash of green to make them stand out against the darker shapes behind them. I continue to develop the shadows and form of the leaves. Finally, I complete the fine detail in each flower.

Traveler's joy

Size: 14 × 21 inches (355 × 525mm)
Paper: Turner gray 90lb. cold-pressed (200gsm)
Brushes: sable nos. 3, 5, 10 or 12

When the leaves fall from the trees in autumn, much of the color is drained from the countryside. It is replaced with a world of softer, more subtle tones and hues just as fascinating for the painter.

My painting of traveler's joy, a plant similar to virgin's bower in the U.S., was done on a gray, overcast day in December which offered just the odd patch of watery sunlight. The soft, muted colors of the landscape made it, or so it seemed to me, a particularly appropriate subject to paint on a colored ground. Thus, for my paper I chose a Turner gray.

Painting on a tinted paper necessitates certain adjustments in technique, but the important point to bear in mind is that a wash of any color, however bright, will become darker. The only way to achieve light or white areas in the picture is to use an opaque medium. Chinese white is one I find the most suitable.

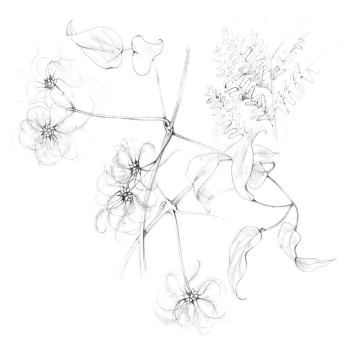

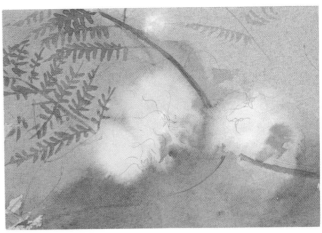
Stage 1

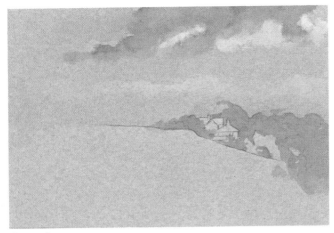
Stage 2

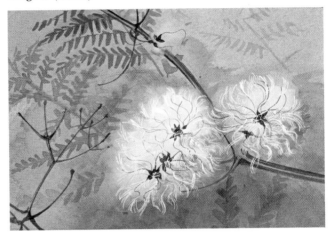
Stage 3 (detail)

Stage 4 (detail)

Stage 1

After making a simple pencil indication of the background landscape, I use a large brush (a no. 10 or 12 sable) to lay a light wash of Prussian blue over the entire sky area. Immediately, while this is still very wet, I add the clouds, using Payne's gray and sepia with just a little Chinese white in places. Just above the horizon I add a touch of alizarin crimson to the clouds. As the paper starts to dry, I begin to paint the distant trees using separate washes of sepia, Vandyke brown, and Payne's gray.

Stage 2

Next I complete the painting of the distant landscape with a minimum of detail in the buildings. I do not want to overwork this area, lest it become too important. In the foreground I cover the whole fern area with a wash made up of varying strengths of brown and yellow ochre. After everything has dried, I lightly indicate in pencil the main features of the fern and the traveler's joy.

Stage 3

Now I wet the whole foreground and, using darker tones of the same browns and ochres as before, start to paint the fern shapes and the shadow areas. While the paper is still wet, I add patches of opaque white for the seed heads and allow it to spread softly into the surrounding color.

Stage 4

As the paper dries, I begin painting all the plant features. I paint as freely as I can consistent with accuracy and preserving the character of the plants. The seed heads are made up of a number of individual seeds, each with a long, hairy 'plume' attached. When the areas of opaque white are dry, I paint the groups of seeds, each with its tail and the 'hairs' of the 'old man's beard'.

Stage 5 – the finished painting (pages 74–75)

I add plants and tone where necessary to retain the balance of the overall composition. In particular, I pay attention to the tone and drawing of the traveler's joy stems. I also add to the fern fronds as and where it seems necessary.

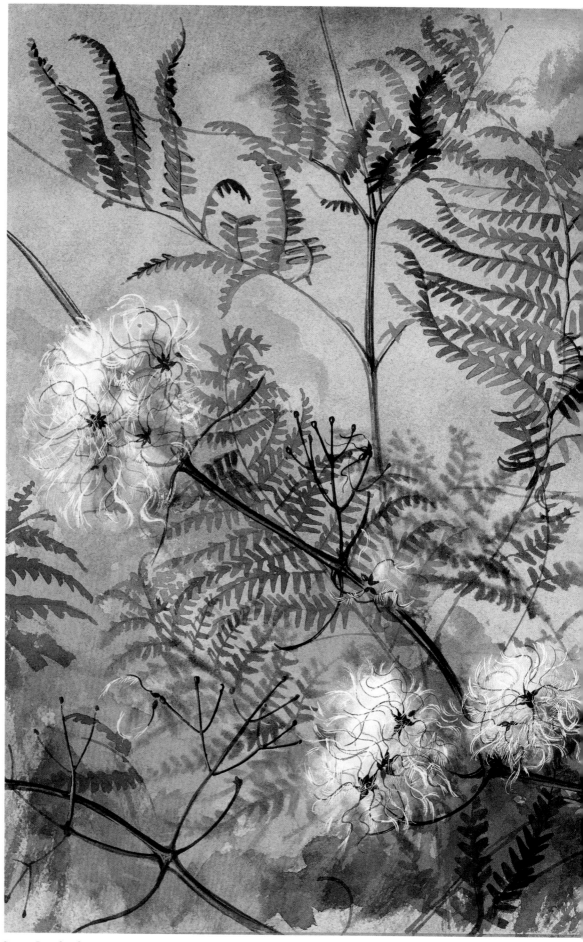

Stage 5 – the finished painting

74

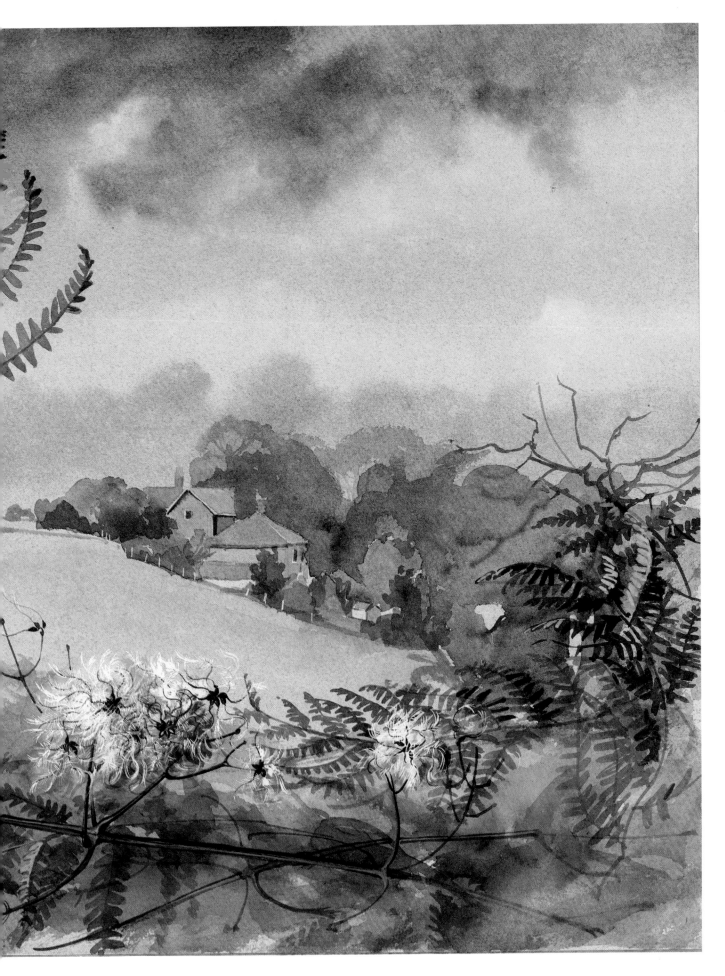

Bindweed

Size: 11³⁄₅ × 8⁴⁄₅ inches (290 × 222mm)
Paper: Royal Watercolour Society 140lb. cold-pressed (300gsm)
Brushes: sable nos. 3, 6, 10

Bindweed is one of the luxuries of late summer as it creeps irresistibly over everything that stands in its path, smothers all the surrounding growth, and triumphantly displays its voluptuous white flowers. It is quite beautiful.

For this painting I selected a patch of bindweed that was gently forcing itself onto some later-flowering rosebay willowherb (similar to fireweed). As a large white butterfly was flying about interested in the pink flowers, I included it as well.

Stage 1 (page 78)

To start, I make a very simple drawing to establish the position of the white flowers and cover these with masking fluid. I wet the paper all over and paint the sky area with a light wash of ultramarine. I immediately follow this with a light wash of cadmium yellow over the background field.

Stage 2

I draw the butterfly and cover that, too, with masking fluid. Then I run a wash of mixed yellow and green over the remaining areas of white paper and paint the group of trees in the distant background. After allowing everything to dry, I lightly draw the main structure of the composition in pencil.

Stage 3

I now start painting the leaves and stems of both plants, paying particular attention to the movement of the bindweed and its contrast to the straight growth of the willowherb. It is this twisting, twining movement that gives bindweed its essential character so, as I paint the leaves, I try to show their general flow and direction.

Stage 4

To paint the willowherb flowers I choose permanent rose, knowing that the blue underpainting will slightly soften this color. I continue to develop the leaves and foliage. Taking a medium-size (no. 6) brush, I paint the dark leaves and shadows, making use of these dark areas to link the elements of the picture and tie everything together. Then I remove the masking fluid and begin to describe the form of the white flowers, using very light tones of Payne's gray and lemon yellow. I also add detail to the butterfly.

Stage 5 – the finished painting (page 79)

First I continue developing the form and shadows of the leaves, flowers, and stems. The greens used throughout are a combination of viridian, Hooker's green, and yellow ochre, while the shadows consist principally of indigo. I strengthen the shadows where necessary and use this darker tone to help hold the whole composition together. Finally, I complete the details I want on all the flowers. The stamens of the willowherb flowers are added with Chinese white.

Stage 1

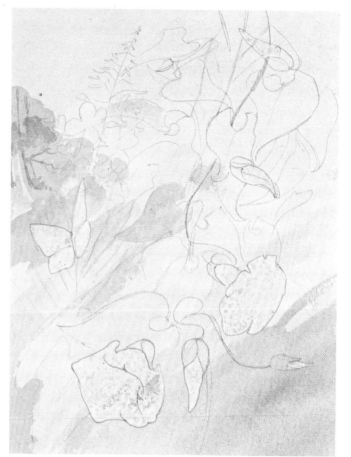

Stage 2

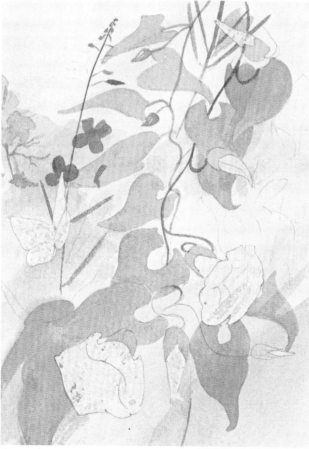

Stage 3

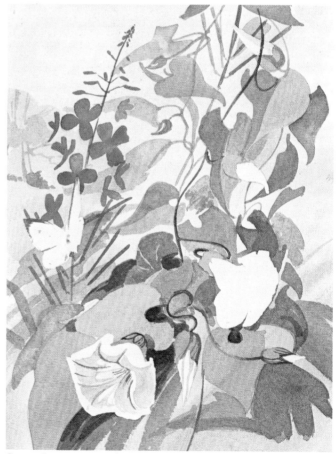

Stage 4

Stage 5 – the finished painting

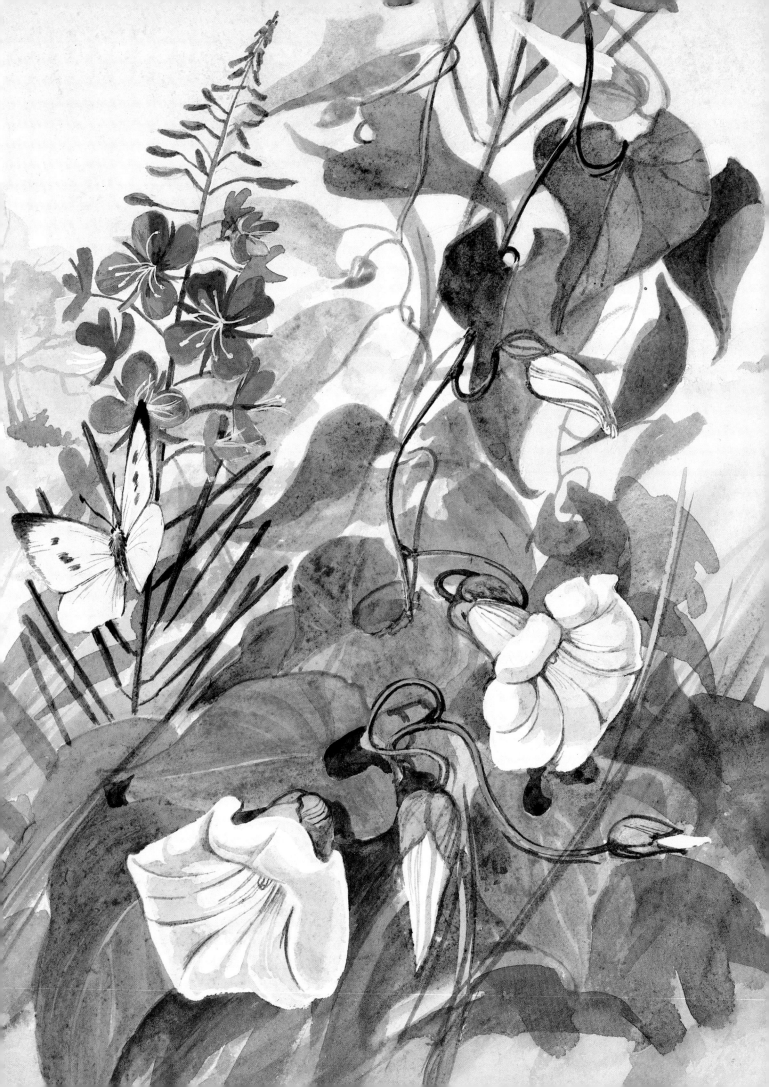

Butterflies and other insects

Flowers that grow in the wild are frequently the center of interest for a variety of insects. Bees, wasps, dragonflies, ladybirds, and beetles are just some of the attractive visitors that might be included as a detail in paintings, but perhaps the most colorful are butterflies.

A butterfly, carefully observed and painted, will add a wonderful touch of color and interest. Of course, careful observation, although possible, is not easy. This is an occasion when a camera can be of great assistance. In any case, whether you use a camera or rely on your own eye, if you persevere and build a collection of sketches, it will be of great value for future paintings.

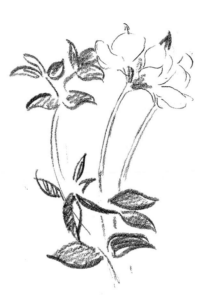

Benjamin Perkins

Focusing on the individuality of plants

Painting is a very individual matter. By describing the way I set about painting wild flowers and similar subjects, as well as some of the techniques that I have developed and find effective, I hope to provide you with useful hints. Do not, however, be discouraged from painting in a freer style if that is what comes naturally to you, or from developing your own methods and techniques. Experimentation is very important in arriving at a style that suits your particular temperament.

Each of my paintings in this chapter is reproduced the same size as the original. For my type of painting, I prefer a hot-pressed paper, which has a smooth surface that will take a lot of detail. If you favor a freer and wetter style, you will probably find cold-pressed or rough paper preferable.

I always use good quality sable brushes and have found that a no. 2 brush answers almost every purpose, although I keep a few larger brushes handy for applying washes. For fine detail, the brush must taper to a perfect point, and even with the best quality sable, the point soon wears away with use. I seldom complete more than two or three paintings without needing a new brush. Although this is expensive, there is nothing more frustrating than trying to paint with a worn-out brush or one where the bristles have sprung apart. Old brushes can always, however, be used for the less detailed areas of a painting.

I do virtually all my flower painting indoors, although I sometimes make pencil drawings outside. For me, a north light is essential. I find direct sunlight, which is constantly changing in intensity, very unsatisfactory. Artificial light is also deceptive when you are trying to mix accurate colors.

I tend to paint across the paper from left to right and always keep a sheet of typing paper under my right hand. This prevents smudging of pencil lines or paint. It also keeps the paper from becoming greasy and in this way resisting the even application of paint.

One other useful tip concerns the flowers themselves. Not all species react in the same way, but many, when cut and put in water, wilt and hang their heads to begin with. In such a case, it is wise not to begin the drawing too soon. Leave the flowers in water overnight, and by the next morning they should have perked up and be looking fresh and healthy.

February bluebells

Paper: Whatman 140lb. hot-pressed (300gsm)
Brushes: sable nos. 2, 5

In the dead of winter it is often difficult to find suitable subjects for a painting. One bleak day in early February, however, I noticed these young bluebell plants and was struck by the contrast of their fresh green colors against a background of dead leaves. The leaves, mainly sycamore, also intrigued me, for they had curled into interesting shapes. Moreover, their colors included a wide range of browns.

Stage 1

I start the painting by establishing the group of three bluebells and giving them a preliminary wash – I use a mixture of sap green and cobalt blue for the leaves and a combination of Naples yellow and Chinese white for the sheaths and leaf tips.

Stage 2

Leaving traces of the initial bluish wash here and there, I build the rest of the leaf surfaces, first with sap green and aureolin, and then with a mixture of sap green, cobalt blue, and Vandyke brown for the shadows. At this stage I draw in the three dead leaves to establish the main compositional thrust: a broad diagonal from top left to bottom right.

Stage 3

I now begin to paint the leaves, starting with pale washes and gradually building the colors and shadows. I find it best to paint one leaf at a time from start to finish, selecting and adding new ones to the composition as occasion demands (I have a box full of dead leaves at my side for this purpose). In the foreground I begin to indicate the moss with many small blobs of pale color – sap green mixed with aureolin.

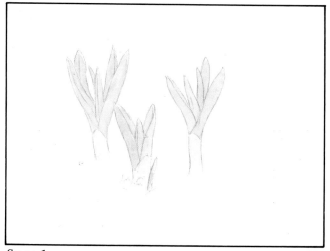

Stage 1

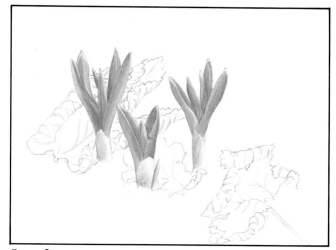

Stage 2

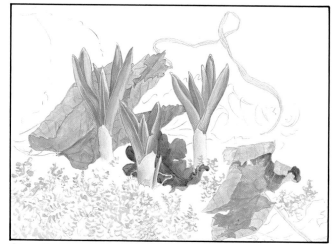

Stage 3

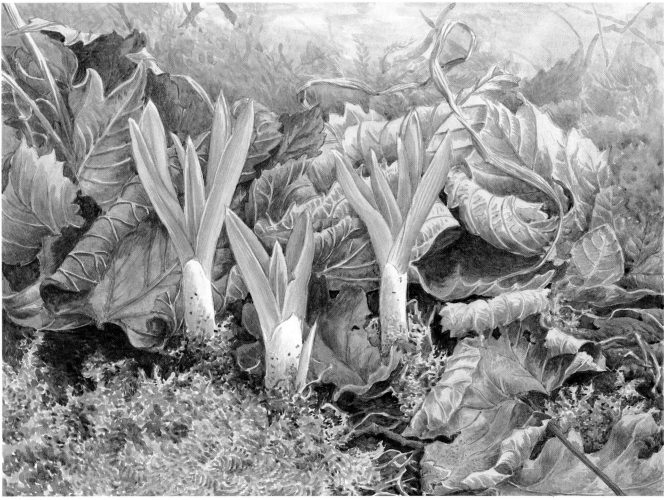

Stage 4 – the finished painting

Stage 4 – the finished painting

Painting the leaves, and seeing the picture come alive as they are given tone and definition, is the exciting part of the painting. I use many different color mixtures. On the reddish leaf behind the left bluebell, for example, I start with a wash of burnt sienna. Next I add cadmium yellow deep to the inside of the leaf and then paint the curled outer surfaces with burnt sienna and cobalt blue. The veins are left unpainted apart from the initial wash and some Indian red and French ultramarine for the shadows. The purplish shadows on the inside of the leaves are painted with a combination of Venetian red and French ultramarine.

To complete the foreground moss, I indicate the shape of the fronds with small brushstrokes and use progressively darker shades of green, as well as green with brown. For the dark woodland soil beneath the leaves, I use warm sepia, mixed, in the darkest areas, with Prussian green. Finally, for the more distant leaves and background wash, I choose various mixtures of colors already in the picture.

Horse chestnut bud burst

Paper: Whatman 140lb. hot-pressed (300gsm)
Brushes: sable no. 2

This exploding horse chestnut bud seems interesting enough in itself to require no background beyond the white paper. It is an example of the sort of picture which, once the pencil drawing has been done, I prefer to paint piecemeal. That is, I paint each component from start to finish before going on to the next.

In this case I start with the central group of bud scales, which I paint one at a time. I then go on to the twig and end with the young leaves. All provide different and interesting textures.

The bud scales, green at the base and glossy brown at the tip, are shiny with resin. To indicate their convex shapes, one must develop the shadows and the curve of the longitudinal striations. I leave areas of white paper to represent the most brilliant highlights, although on other occasions I have used blobs of white gouache as highlights. For the glossy brown areas, I use first burnt sienna, then I apply burnt umber with crimson lake.

To suggest the slightly roughened surface of the twig, I use many very small brushstrokes while building up the shadowed area. The little oval warts are added afterward by first lifting, then adding shadow. The color of the horse chestnut twig is interesting. I use a mixture of Indian red and yellow ochre for the lit area at the top, with Winsor violet mixed in for the reflected light on the underside of the twig, and burnt umber with Winsor violet for the darkest shadows in the middle.

The young leaves are covered with a mesh of silky hairs, which gives them a silvery color, particularly on their undersides and on the stalks. In the case of the two leaves at the tip of the twig, there is a nice contrast, with one showing its pale underside and the other its green upper surface. The clusters of pinkish and green flower buds provide another point of interest.

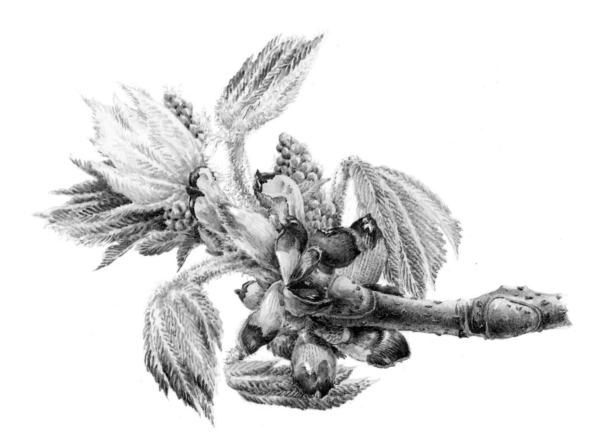

Shaggy ink cap

Paper: Whatman 140lb. hot-pressed (300gsm)
Brushes: sable no. 2

These mushrooms, called shaggy ink caps or 'lawyer's wigs', are a common autumn species. With their spindle shapes, pure white coloring, and shaggy texture, they 'ask' to be painted.

Stage 1 (page 88)

The three mushrooms – one young, one full-grown, one mature and starting to decay – make a simple, triangular composition. I start by drawing them lightly with an H pencil, also indicating the main lines of the surrounding grass.

Stage 2

Next, having added a fallen oak leaf, which will give a touch of extra color to the picture, I put on a background wash of sap green and raw umber – not evenly, but with fairly short brushstrokes, following the random lines of the grass stems. I then paint the caps and stems of the mushrooms with Chinese white, and the membranes covering the tops of the caps with raw umber, leaving a very pale area on the side from which the light is coming.

Stage 3

Now I add the main shadowed areas on the caps with a mixture of cobalt blue and a little Vandyke brown, and those on the stems with cobalt blue and raw umber. The shadows immediately below the caps are the darkest. It is important, however, to leave areas of white at the edges of the shaggy tufts which cover the cap. Although the surface of the cap may be in shadow, the tufts protrude and catch the light.

Stage 4

From this point onward I complete each part of the painting in turn, dealing first with the mushrooms and then with the background. I use short, fine brushstrokes to give an impression of the fibrous texture of the cap. For the 'dripping' edges of the cap of the tall mushroom, I use black paint, which I seldom have occasion to use in botanical paintings.

Stage 5 – the finished painting (page 89)

Touches of Winsor violet and raw umber are added to the shadows on the caps; the deepest shadows are intensified with further applications of cobalt blue and Vandyke brown. Details, such as the specks of dirt and the cracks in the caps, are added with a very fine, almost dry brush. Lastly, the moss, grass stems, and clover leaves are put in with freer brushstrokes. For this I use several different shades of green and vary the intensity to give an impression of light and shadow. The shadows on the oak leaf and the deep shadow cast by it augment the feeling of light.

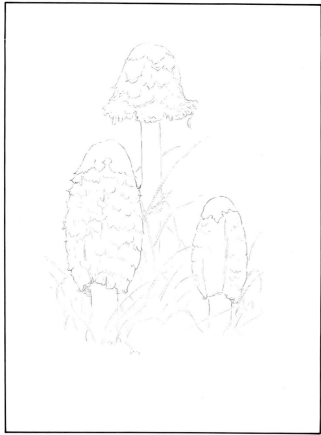

Stage 1

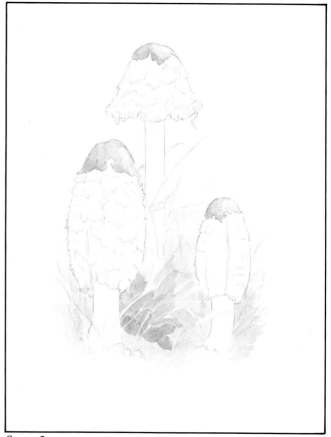

Stage 2

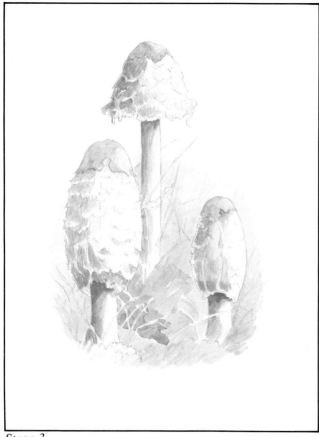

Stage 3

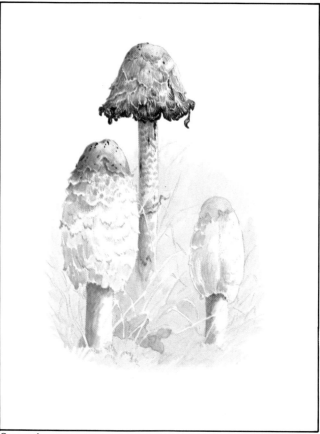

Stage 4

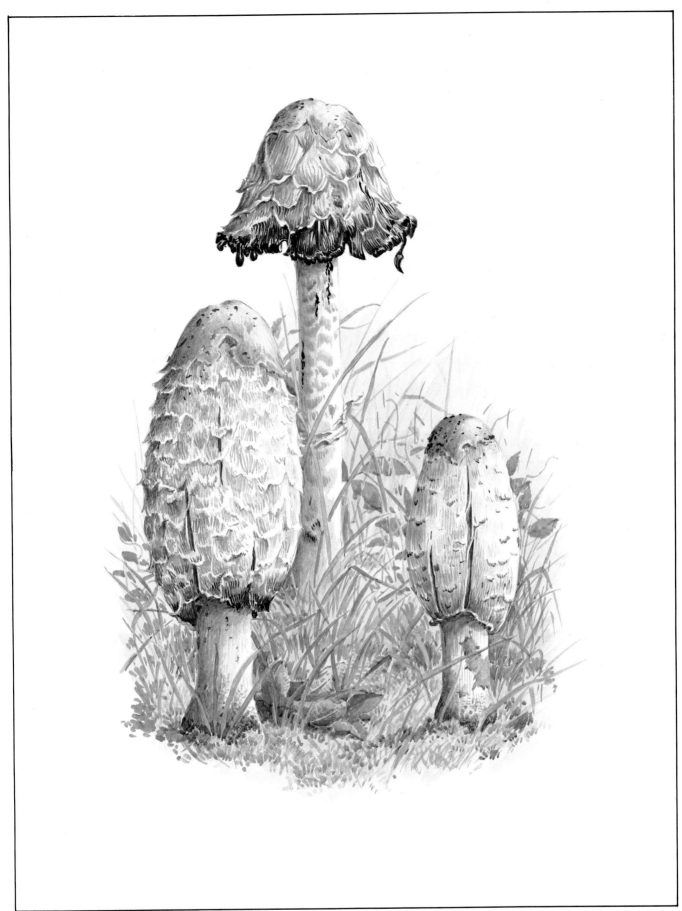

Stage 5 – the finished painting

Dog rose

Paper: Whatman 140lb. hot-pressed (300gsm)
Brushes: sable no. 2

In this picture I have chosen to focus attention on the plant, its leaves and flowers, by painting it on white paper with no background details or wash. The pale-colored flowers stand out by contrast with the dark green leaves behind them.

The first two demonstrations show how I have set about painting the flowers. The second two demonstrations deal with the leaves.

Flowers – Stage 1

The initial washes are laid on one petal at a time, since I want the two colors involved to merge into each other. First, I paint the base of the petal with a mixture of Naples yellow and viridian, and extend the wash in a very diluted form to cover the remaining surface of the petal. While this is still wet (and there is little time to spare if you are working on hot-pressed paper), I fill in the outer edge of the petal with permanent rose. The hoped-for result is a smooth transition from pink to yellow.

Flowers – Stage 2

Here I paint the anthers with cadmium yellow. I also enhance the pink extremities of the petals with fine lines of rather more concentrated permanent rose to indicate the veining. Finally, I use a mixture of raw umber and viridian for the shadowed area surrounding the stamens.

Leaves – Stage 1

The leaves have already been given an initial bluish-green wash, and the shadowed areas have been lightly suggested. Now I elaborate on this process by defining the shadows more precisely and laying in secondary washes where necessary to vary the tones. It is important to realize that all the leaves on a single plant are not exactly the same color; not only do they vary intrinsically, but some may reflect light from the sky, others have light shining through them, and others may be in the shadow cast by other foliage.

Flowers – Stage 1

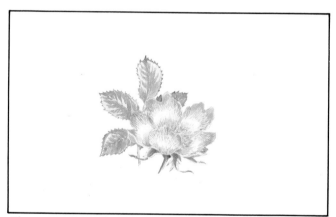

Flowers – Stage 2

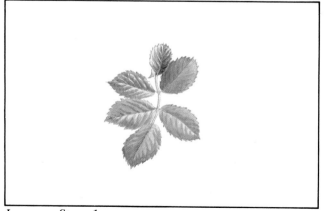

Leaves – Stage 1

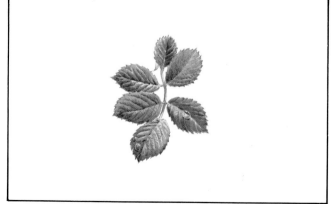

Leaves – Stage 2

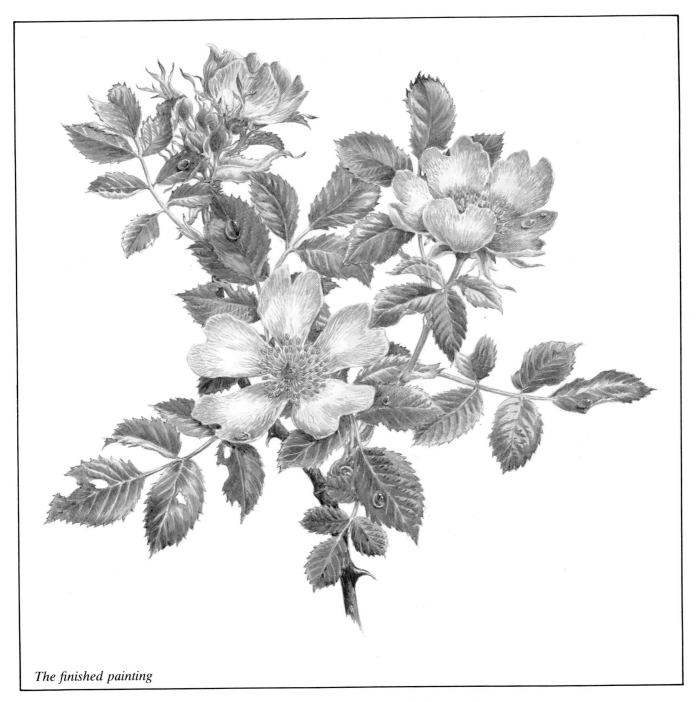

The finished painting

Leaves – Stage 2

A final darkening of the shadowed areas and the addition of some details of veining where necessary complete the painting of the leaves. Now it is time for the dewdrops (or raindrops)! I find it much more effective to add these at this late stage than to allow for their presence at the outset. They show up better against a fairly dark background.

Using a fine brush loaded only with a small quantity of clean water, I first outline the droplet by washing away the underlying paint. The brush, by the way, requires frequent cleaning during this process. Next I add the shadows inside the droplet and the very dark shadow cast by it onto the leaf. Finally, I paint the highlights with minute spots of barely diluted white (for this I generally use gouache).

The finished painting

To complete the painting of the flowers, I add the shadowed areas inside the petals with a mixture of permanent rose, cobalt blue, and Vandyke brown. For the anthers' shadows, I use burnt sienna. I then combine raw umber with viridian to darken the central shadowed area and to define the pale filaments of the stamens.

To make the flowers stand out against their background, I darken the leaves immediately behind the flowers. (Look at a pale flower in your garden and you will discover that an optical illusion creates just such an effect in nature.) Care, however, must be taken, so that this does not result in a dark line around the edges of the petals. The dark surround must be diluted outward to merge into the green of the leaf – unless, of course, you want a hard shadow, which is something quite different.

Honeysuckle

Paper: Whatman 140lb. hot-pressed (300gsm)
Brushes: sable nos. 2, 5

The delight of honeysuckle lies in its subtle but varied colors and in its swirling, elegant shape. The colors are fugitive and have to be caught quickly before they change. Pink-tinged buds open as white flowers, which soon become a creamy yellow and finally a rich orange-yellow before dropping.

For this demonstration I have used a single flower, which is just beginning to turn from white to yellow. My aim is to show you how to build the colors and, in particular, how to make such delicate organs as the stamens and pistil stand out against the background of a green leaf. An alternative method would be to overpaint the background using an opaque white paint, but, personally, I do not find that this method gives such satisfactory results, although it may be easier.

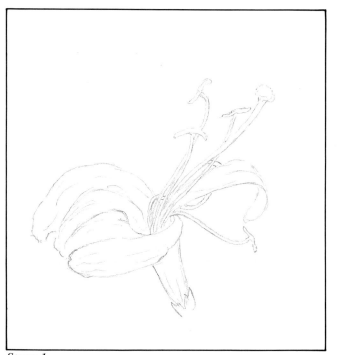

Stage 1

Stage 1

I first draw the flower lightly with an H pencil.

Stage 2

The basic colors I use for the flower are Chinese white and Naples yellow, with just a touch of cadmium lemon. The stamen filaments are white, and for the anthers I use chrome orange with cadmium yellow.

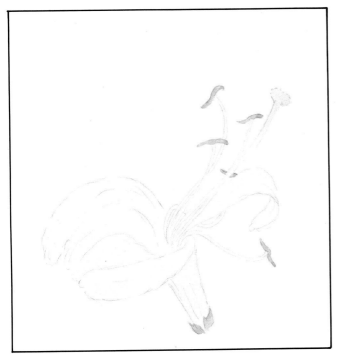

Stage 2

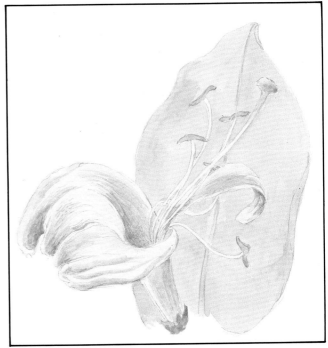

Stage 3

Stage 3

For the shadows on the flower I use viridian and raw umber, with cobalt blue added for the darker patches. All the brushstrokes follow the natural curvature, folds, and veining of the flower. I also heighten the color of the throat of the corolla with more cadmium lemon. At this stage the leaf in the background is given an even wash of pale green: I use a fine brush and take great care not to overpaint the narrow filaments.

Stage 4

I now gradually build the color of the leaf. I use darker greens and leave narrow areas of the initial wash to form the leaf veins. Finally, I define the edges of the stamens and pistil where necessary and add the shadows on the anthers.

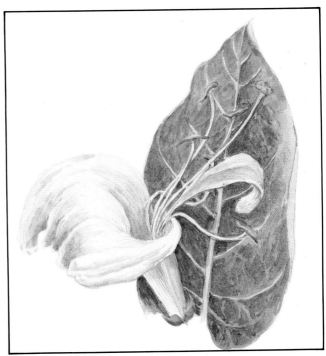

Stage 4

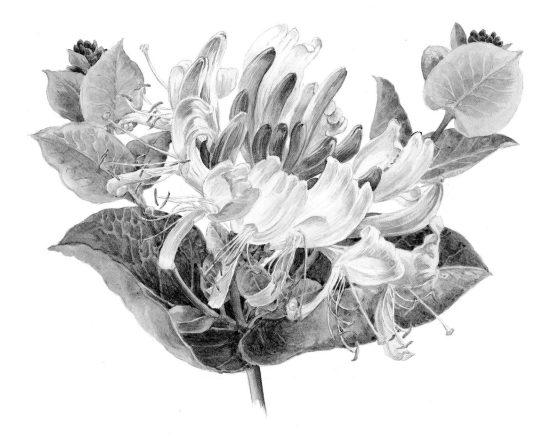

The finished painting

For the finished painting shown here, I repeat the process
I have described several times over, although none of the
individual flowers that make up the inflorescence is quite
the same. Not only do they differ in color according to
their stage of growth, but also each faces in a different
direction, so the shadowed areas vary. Obviously, it is
important to be aware, right from the start, of the direc-
tion of the light source. Besides the contrasts provided by
light and shadow, there is also the contrast of pale flowers
against the darker buds in the center of the cluster and
against the green foliage beneath them and on each side.

Violets

Violets tend to grow in woodland or in the dappled shade of hedgerows and meadow borders. Since they flower early in the year, before there is too much competition from larger and coarser plants, their delicate flowers – carried on slender, swan's-neck stems – and small, heart-shaped leaves are generally seen against a background of moss, twigs, dead leaves, and bare earth.

I find that the best method is to draw and paint the violets themselves first, then add the background. In this way you avoid too much confusion in the pencil drawing – which makes it much easier to paint the plants. It also means that you can arrange the background in such a way as to make the flowers and stems stand out to best advantage.

There is a great variety of color among the flowers of the wild violet, from deep purple to almost blue, with the sweet violet also having magenta, pink, and pure white flowers. To obtain the right shade of bluish purple for the flowers of this little group, I add cobalt blue to Winsor violet.

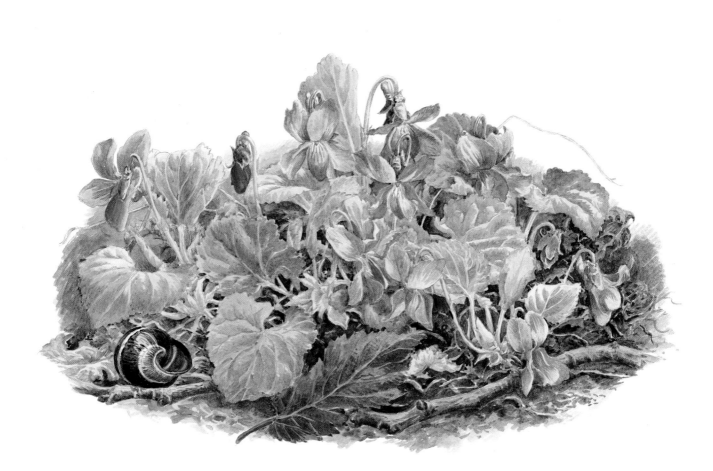

Poppies

Paper: Whatman 140lb. hot-pressed (300gsm)
Brushes: sable nos. 2, 5

In this painting I have allowed the poppy flowers, with their brilliant color, delicate texture, and graceful shapes, to dominate the picture. The grass stems, apart from a few in the foreground, have been added at the end, in a more impressionistic manner, so as not to distract the eye from the poppies.

Stage 1 (page 97)

Since the poppies are to be the main compositional component, I establish their relative positions first. I also locate the opening bud, which, with a touch of scarlet, will become an important part of the finished picture. With the foreground grass and the poppy leaves, the most significant part is the grass stem that crosses in front of the flowers and emphasizes the thrust of the composition. This deviates only slightly from the vertical, suggesting a gentle breeze from the left, and helps to put the poppies into perspective.

The wash of yellow ochre and Naples yellow covers all but the poppies themselves, as their scarlet coloring requires a white ground to achieve maximum brilliance. This wash may seem rather blotchy because of the painting surface, but this should not affect the end-result.

Stage 2 (page 98)

I next paint the poppy leaves and grass stems, using various shades of green and umber. The heads of the fox-tail grass are a mixture of sap green and raw sienna.

Stage 3 (page 99)

Having added a second, bluish-green wash to the bottom of the picture, I give the poppies their initial wash. This consists principally of cadmium red with a touch here and there of scarlet lake and cadmium yellow deep. The brushstrokes radiate out toward the edges of the petals, reflecting the direction of the natural folds. Notice that the paint is applied with varying intensity, which creates the effect of light and shadow. A little gum arabic is mixed into the paint to help simulate the silky texture of the petals.

Stage 4 – the finished painting (page 100)

The poppy petals are now completed in three stages: first, I put in the fine creases and wrinkles in cadmium red; next, I darken the shadowed areas with crimson lake; last, I add the darkest shadows of all with a mixture of crimson lake and French ultramarine. Throughout this process I mix gum arabic into the paint.

Other details are now added, such as the blue-black anthers of the uppermost poppy, the reddish hairs that clothe the poppy stems and bud scales, and the details of the foreground grass. Finally, using a mixture consisting mainly of cobalt blue and raw umber, I sketch in the background grass. This can be done freehand if you feel confident enough; otherwise, you can softly pencil in the shapes beforehand.

That was my method of painting this picture. Another artist, however, might prefer to complete the background first, leaving the poppy heads until last.

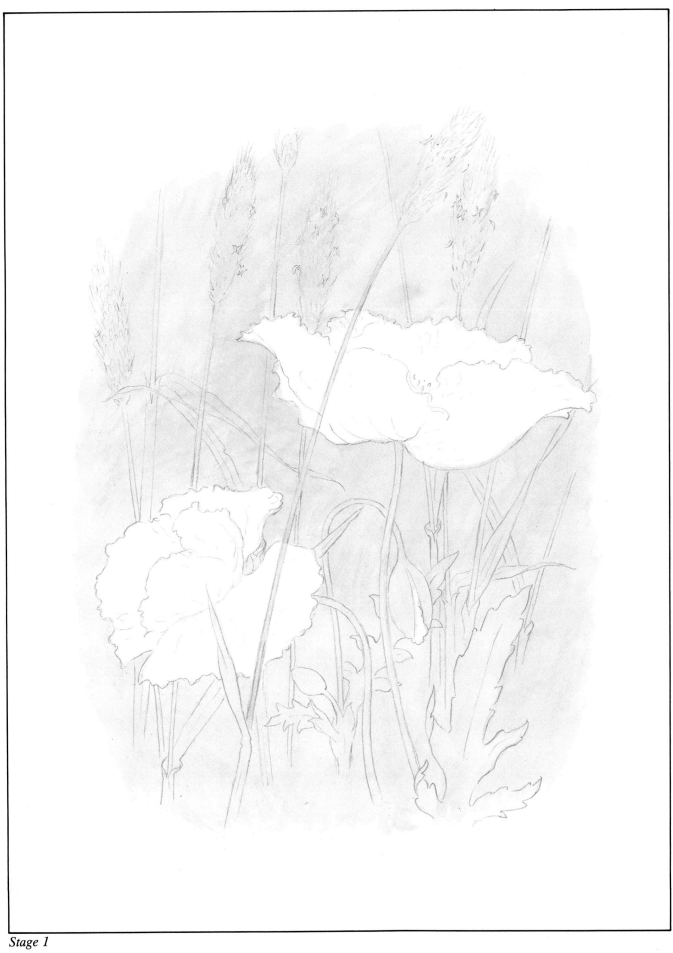

Stage 1

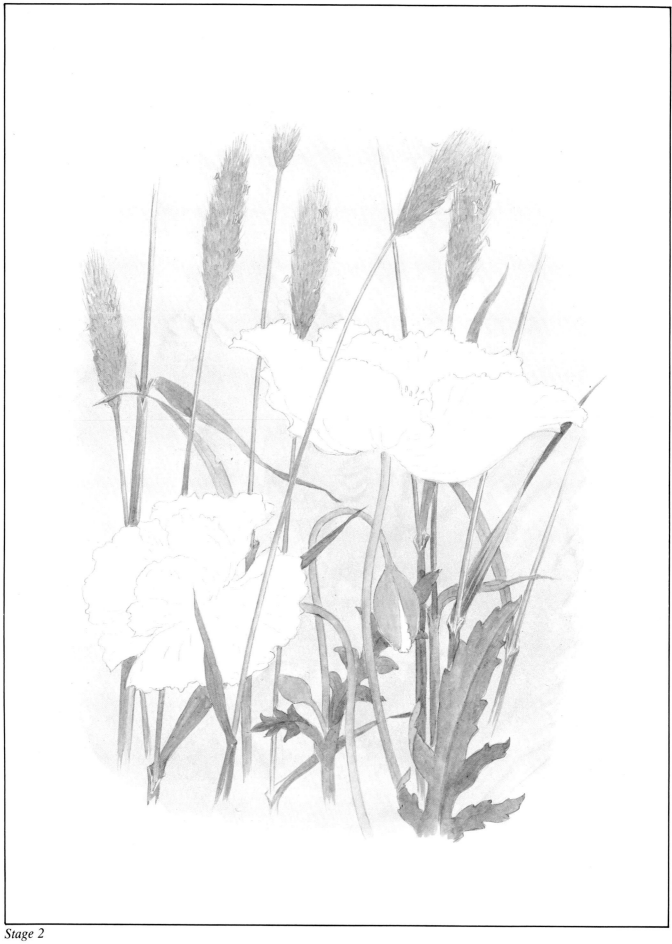

Stage 2

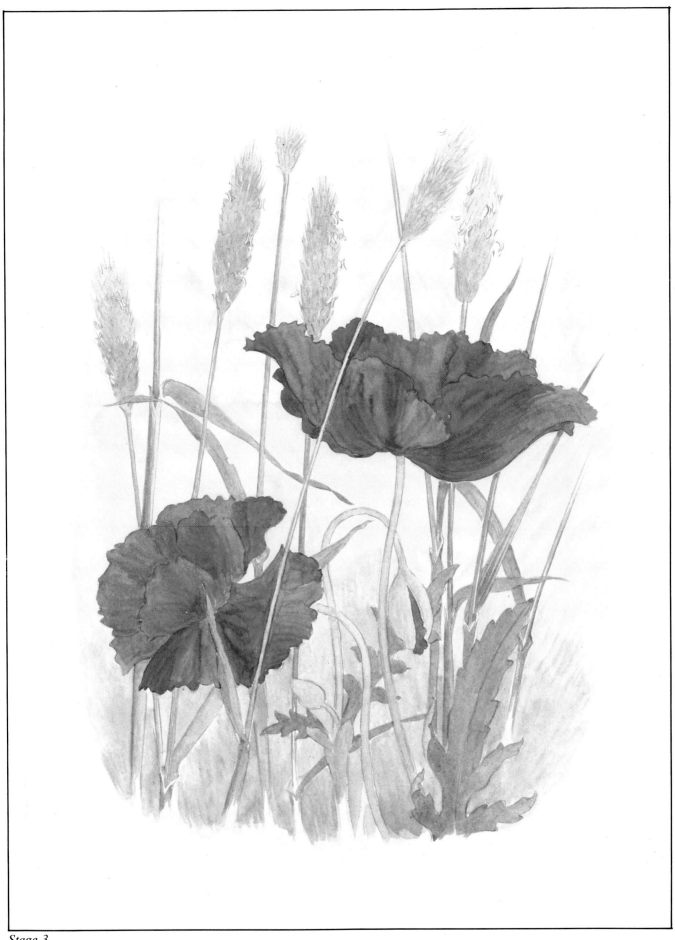

Stage 3

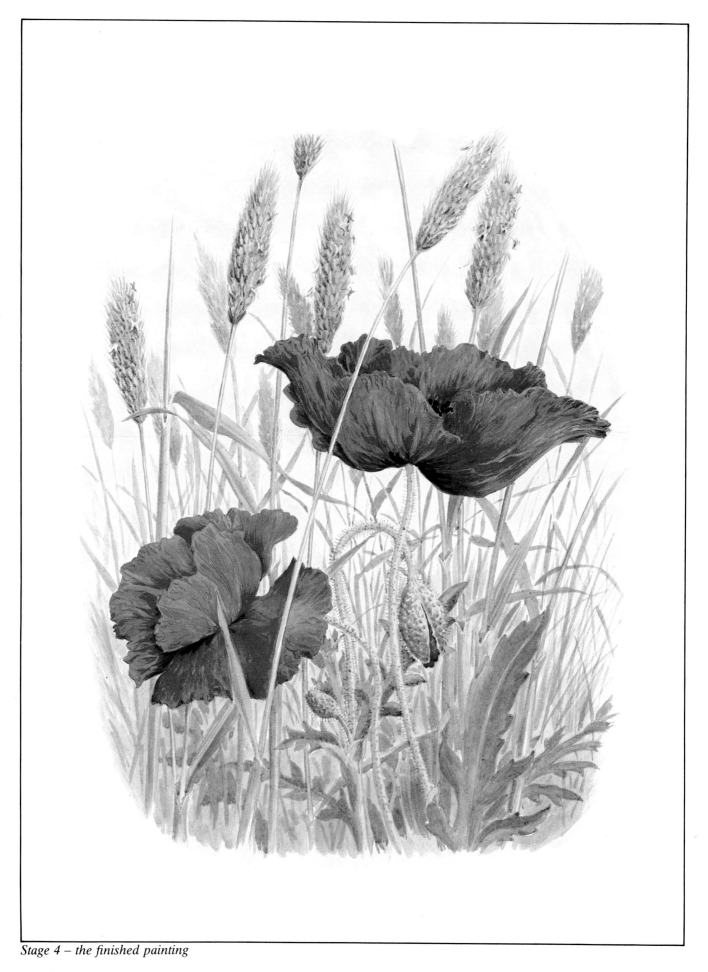

Stage 4 – the finished painting

Snowdrops

Paper: Whatman 140lb. hot-pressed (300gsm)
Brushes: sable nos. 2, 5

Snowdrops are often found growing at the edges of woods or on shady banks, so it seems natural to paint their pure white flowers and blue-green leaves against a dark background. I have backed my clump of snowdrops with dark ivy leaves in the upper part of the picture and dead oak leaves in the lower part to give the impression that they are growing at the base of a garden wall.

Once potted and brought into the house snowdrops expand and grow very quickly. They must, therefore, be drawn and painted very quickly – in one session if possible. Here I completed the painting of the snowdrops themselves before I drew or started to paint any of the background features. I did, however, have a clear idea in my mind of what elements would be in the background and how they would be disposed. The snowdrops were soon returned to the garden, none the worse for their experience.

To illustrate the process clearly, I have demonstrated the development of a single snowdrop, similar to those in the final painting.

Stage 1 (page 102)

After I draw the snowdrop in pencil, I begin, as always, to lay in the initial washes, consisting of the palest colors. On the petals I use Chinese white, which looks rather creamy against the white paper but which will appear dazzlingly white when the dark background has been put in.

Stage 2

The leaves of the snowdrop are bluish-green in their upper parts, with ivory tips; they become yellowish-green toward the base of the plant, where they are enclosed by a pale, membranous sheath. I build the colors up gradually using cobalt blue and aureolin at the base and, for the rest of the leaves, a little sap green with either cerulean mixed with white or, for the darker shadows, Payne's gray and white. The brushstrokes follow the vertical veining of the leaves. For the shadows on the white petals, I use a mixture of French ultramarine and Vandyke brown.

Stage 3

Once the snowdrop itself is complete (apart from some final touching up and enhancing of shadows), I draw the background features in pencil and give them their pale initial washes. In the case of the ivy leaves, this wash consists of a diluted mixture of cobalt blue and aureolin. It remains visible along the veins of leaves when the next, darker layer of green (sap green with burnt umber and Prussian green) is applied.

Stage 4

Some of the ivy leaves have purplish areas between the veins, for which I use crimson lake and French ultramarine. For the earth and shadowed areas behind the ivy leaves, I mix warm sepia, sometimes with Hooker's green and sometimes, particularly for the very dark shadows behind the ivy leaves, with Prussian green. The moss, roots, and stems I add as I go along.

The finished painting (page 103)

To finish the picture, I go carefully over every part, adding touches of color, deepening shadows where necessary to provide more contrast, occasionally lifting small areas of paint to give the effect of reflected light, and defining the edges of all the leaves and, in particular, the petals. Because I want the white flowers to stand out against the gloom of the background, I take special care to darken their immediate surroundings. If you glance back to Stage 3, you can see how important this is: there the flower, seen against a pale green leaf, is almost lost to sight. Look at snowdrops in their natural setting, and you will see how the brilliance of their white flowers seems to create an aura of darkness behind them.

Stage 1

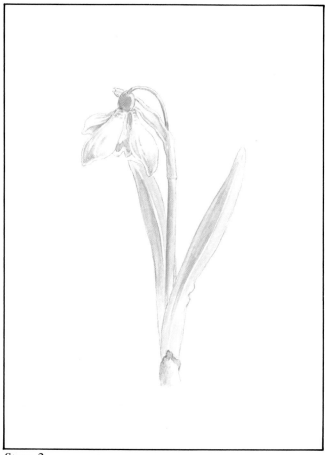

Stage 2

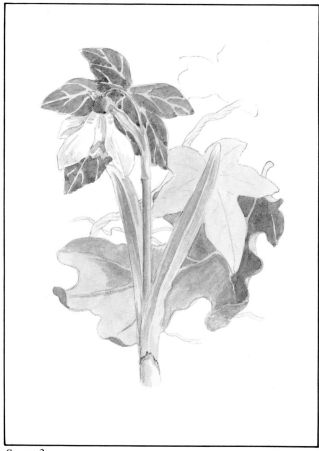

Stage 3

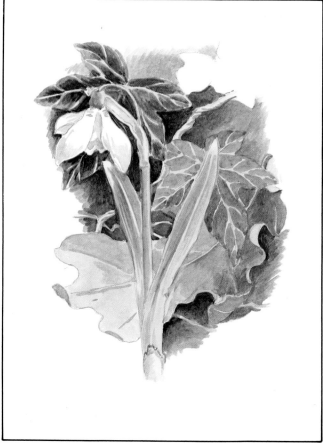

Stage 4

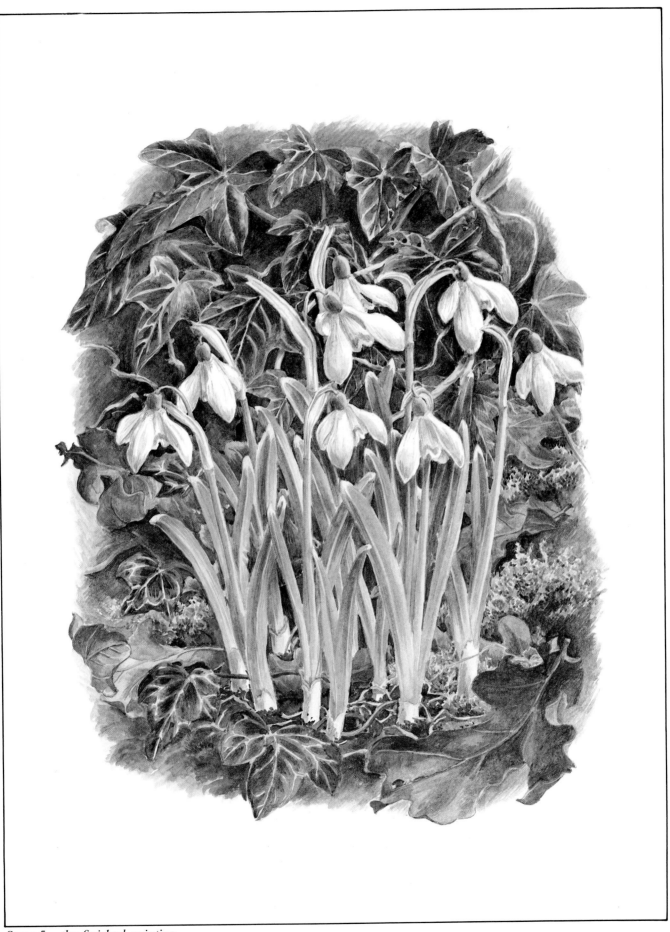

Stage 5 – the finished painting

Mixed wild flowers

Paper: Whatman 140lb. hot-pressed (300gsm)
Brushes: sable no. 2

Here I have chosen three kinds of wild flowers – birdsfoot trefoil, white dead-nettle, and yellow vetchling – to make a simple composition. The colors, apart from a small touch of red, are limited to green, white, and yellow. But there is a lot to interest the eye: not only the flowering stems, but also the leafy stalk of vetchling, with its curling tendrils.

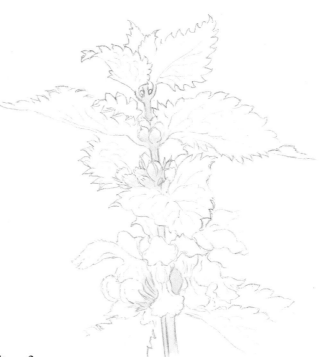

Stage 1

Stage 2

Drawing

I start with a rough sketch to establish the composition and the major areas of dark and light. For this sketch I use a slightly softer pencil (HB) than I would for a drawing over which I intended to paint. When I paint large compositions of this type, using a greater diversity of wild flowers, it is impossible, owing to the time factor and the continuous growth and movement of the plants, to plan the composition in advance. Instead, I draw and paint one specimen at a time, adding others and building the composition as I go.

Single flower – Stage 1

To demonstrate my process, I have chosen to show only the white dead-nettle, so that you can see each step in greater detail. This initial drawing is done with an H pencil. Although more difficult to erase smoothly, should the need arise, this pencil has the advantage of being less likely to smudge than the softer HB.

Single flower – Stage 2

Once again, I apply the palest colors first. In this case I choose a pale green (viridian with raw umber and aureolin) for the stems and sepals, and Chinese white mixed with a very small quantity of Naples yellow for the flowers.

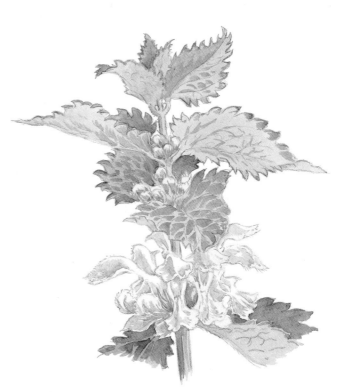

Stage 3

Single flower – Stage 3

In the next stage the preliminary washes on the leaves – which are by no means all the same shade of green – the purplish edging to the teeth of the leaves, and the light and dark areas, all begin to be defined. The shadows on the white flowers are made with a mixture of cobalt blue and raw umber.

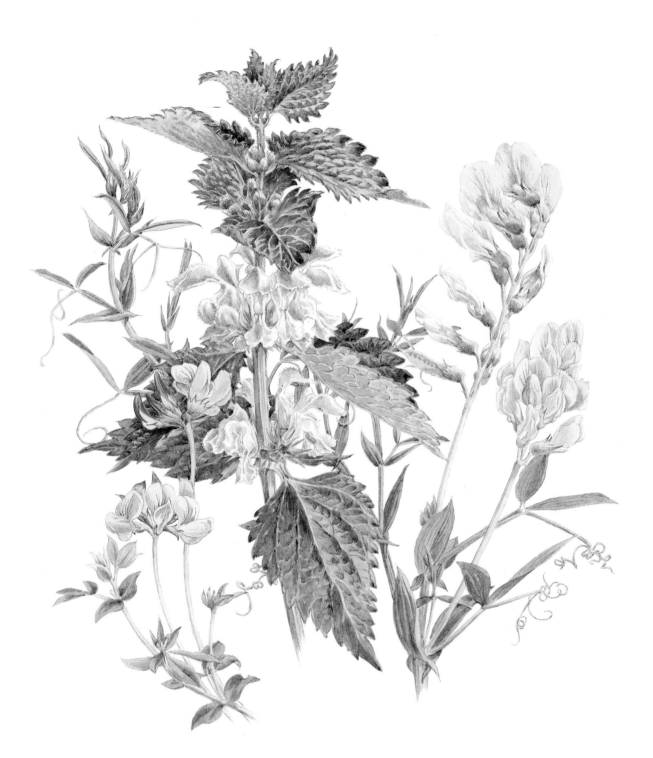

The finished painting

As finishing touches, I add such details as the leaf and flower veins, and the dark points of the sepals. I keep adding to the dark areas until I am satisfied that there is sufficient contrast. In this case I have relied chiefly on shadows to make the white flowers stand out, instead of putting them against a dark background (see the snowdrops on page 103). Note that even very fine elements in the drawing, such as the vetchling's tendrils, require shadows; otherwise they would look flat and un-alive. To do this you need a very fine brush; for anyone with less than perfect eyesight, a magnifying glass can also prove useful.

Velvet shank

Paper: Whatman 140lb. hot-pressed (300gsm)
Brushes: sable nos.1, 2

Many species of fungi make attractive subjects for the painter. Velvet shank, a common winter fungus in England, which grows from the bark of dead or dying trees, has several characteristics to commend it for the artist. It grows in tiered groups, which often lend themselves to a pleasing composition, and the bright chestnut caps and pale yellow gills contrast well with the velvety, dark-purplish stems.

Removing a suitable cluster from the tree requires care for the fungi are very brittle. After you have taken them into the studio and arranged them to your liking, do an outline drawing immediately. All fungi, if kept in a warm dry atmosphere, will quickly dry up and wither, so between working sessions they should be put outside, preferably in an open shed. There the natural humidity in the air should preserve their fresh appearance for several days.

Stage 1

Stage 1

The first step is to decide on the composition – and there is no reason not to improve on nature by removing or adding an individual fungus if the balance of the picture seems to require it. I then draw the whole group lightly in pencil, incorporating important details such as the divisions of the gills. At this stage I indicate only a few of the most prominent features of the background, like the large knot in the top right corner.

Stage 2

Next I lay in the first pale washes, consisting of the lightest colors in each part of the fungus. The caps are done with yellow ochre (apart from a couple of small areas of Winsor violet). While these are still wet, I mix some light red into the darker central, or shadowed, areas. The gills and stems are given very diluted washes of, respectively, Naples yellow and burnt sienna. For these washes I use a no. 2 sable.

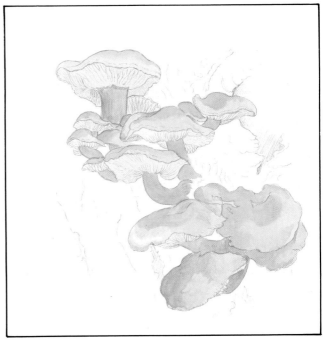

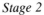

Stage 2

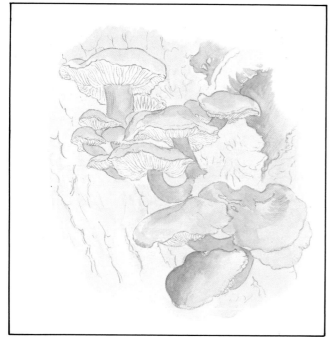

Stage 3

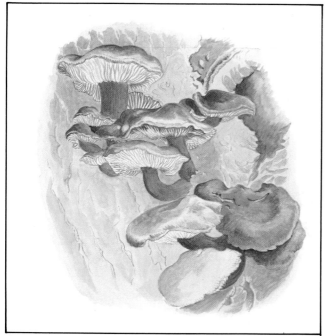

Stage 4

Stage 3

Now I give the background a pale wash of Hooker's green mixed with aureolin, which is the basic color of the algae covering the bark. You might prefer to put this wash in right at the start, as you would certainly do in the case of a landscape; however, in paintings of this kind, I often leave it until the last moment.

Stage 4

From now on I use a drier brush and, for the finer details such as the gill divisions, a smaller one (no. 1). I build the colors gradually, using successive layers of paint. The light parts of the caps are brightened with more concentrated yellow ochre and with cadmium yellow, the dark parts are enriched with light red and then with a mixture of light red or burnt sienna and Winsor violet. The gill divisions are drawn in with yellow ochre and light red, and the stems are given a second coat of burnt sienna. The rather bright green background is muted with a secondary wash of Hooker's green and Winsor violet, but parts of the original bright green are left exposed to suggest light.

Stage 5 – the finished painting

In the final stage the buildup of colors is continued until the desired intensity is achieved. I add shadows, some of them green-tinged, to the gills, particularly under the rim of the cap, and give the stems their rich, deep color and velvety texture with applications of Winsor violet, crimson lake, French ultramarine, and warm sepia.

Once the fungi are complete, I draw in the cracks and corrugations of the bark (the larger cracks revealing reddish-brown wood underneath). Finally, and very important, I put in the main shadows, using primarily burnt sienna, Vandyke brown, Winsor violet, and French ultramarine. These final touches give a feeling of life and light, and add a third dimension to the picture, as you will readily see by comparing this stage to the previous one.

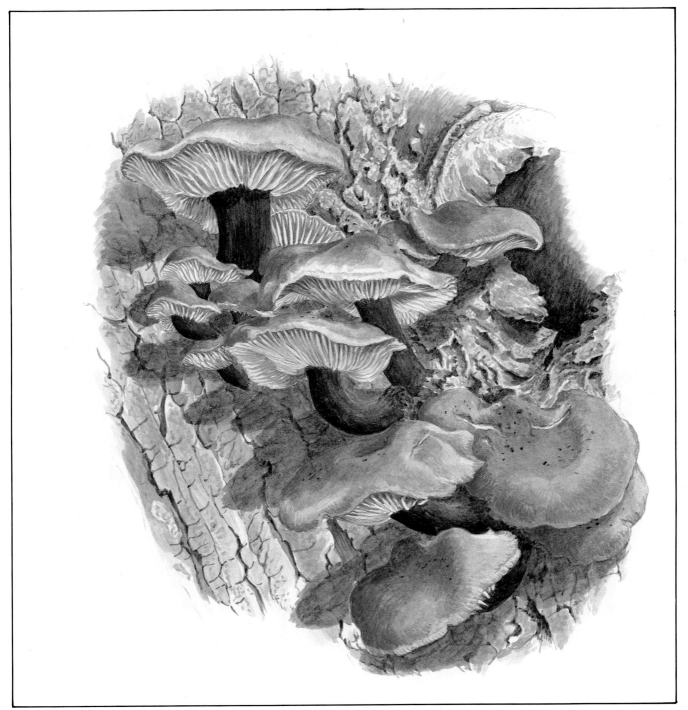

Stage 5 – the finished painting

Rosanne Sanders
Developing themes

It was when I was living in a small flat in London, with no garden or even a balcony on which to put a flower pot, that I began painting flowers. Maybe it was a subconscious desire to return to the country and the lovely garden where I grew up; more probably it was because I could take flowers home with me and paint them, even in the middle of winter. Whatever the reason, I have been painting flowers ever since.

I have, however, always found it most exciting to paint wild flowers, which have an unassuming beauty, unsurpassed by their more glamorous garden counterparts. There is nothing quite like coming across a patch of wild flowers growing and flourishing in some unexpected spot, against all the odds.

I find a great deal of my inspiration when I am out walking, but unfortunately I see many more things than I ever have time to paint. Recently, at a nature reserve near the coast, my eye was continually caught by the many sights in the late afternoon sun: from the twisted bole of a tree, to some iris leaves emerging from dark brackish water; from the sun glancing through them, to the delicate, flowering grass. It does not matter where you are – on a disused building site, in a local park, or in your own garden – there is always something of interest to paint.

I like working on themes – for example, the seasons of the year– rather than individual paintings. It is also quite interesting to take a small area of hedge, wood, or garden, and do four paintings, showing the flora and fauna to be found in each season. I have also made circular paintings of trees and shrubs showing the progression through the year from bud to flower to leaf to berries.

Sketching is most important, for it trains the eye wonderfully. Any spare time you have, take a pad and pencil and sketch something. Be completely selfish and put drawing and painting first if that is what you want to do. When I began to paint, I found it difficult to explain to others that I wanted to paint: it was hard to justify the time spent when the rewards were nil. There are so many other demands on your time that, unless you are determined, you will not succeed.

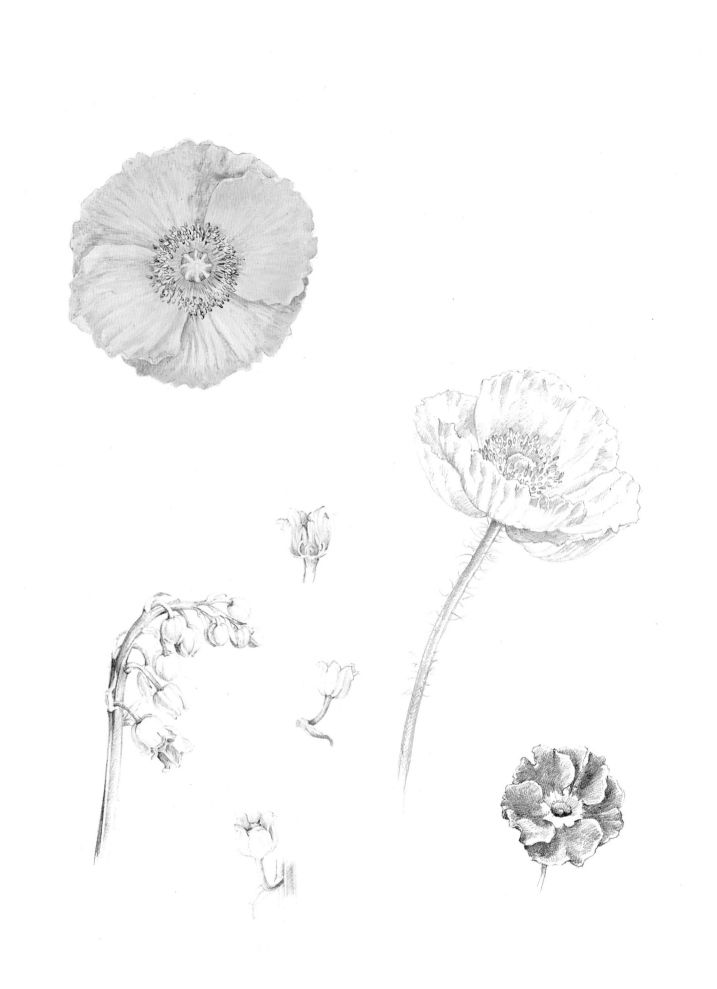

Paper

One of the most crucial aspects of painting, and particularly of botanical painting, is to find a paper that suits your style. What suits one person may not, of course, suit another, so it makes sense to try out as many papers as possible to assess the qualities of each. Always, however, buy the best-quality paper you can afford. Paper of inferior quality, although good for sketching, will quickly deteriorate and discolor. Handmade rag paper is best. The old linen rag papers are superb to work on, but unfortunately today's papers do not compare. There are, however, some quite acceptable mold-made papers, among which Arches paper is quite satisfactory and consistently so.

Be sure to consider the weight of the paper. The lighter weights need stretching to prevent wrinkling when washes are laid on, but the heavier grades may not, unless you plan large wash areas. A heavier paper also makes the problem of handling easier, especially if the work is to be reproduced. (Keep in mind that paper should always be held lightly with two hands at opposite corners. If you grip it at the bottom with your thumb, you are likely to leave a crease or imprint.) Although illustration board solves the problem of buckling, it is not advisable if the work is intended for reproduction as the paper will need to be stripped from the board.

The surface of the paper is important. It comes in three grades: hot-pressed, cold-pressed, and rough – although even within these categories, surfaces differ considerably. Hot-pressed paper is good if you want finely detailed work, especially if the work is for reproduction. I normally paint very dry – in fact, I 'draw' with paint – so hot-pressed paper suits me well. A cold-pressed surface, however, is far better for washes, and detail can be captured perfectly satisfactorily on it. A rough surface is not good if the painting is for reproduction, but it does make the painting very lively. The very rough papers, however, are not suitable for botanical painting.

Stokenham

Size: 7½ × 11 inches (190 × 280mm)
Paper: Fabriano 140lb. rough (300gsm)
Brushes: sable nos. 1, 2

We are lucky in the south-west of England, and on the Devon coast in particular, because there are still a great many wild flowers to be found. Even in winter some flowers still linger, but during the summer the banks are covered with them. My painting on pages 116–117 shows some that grow in the summer in the lane outside my cottage, which leads to the village of Stokenham.

Preliminary work

I want to sketch the village from the lane, but to give the picture a more three-dimensional effect, I decide to enclose it in a border of flowers. After outlining the basic shape I want, I select some flowers from the lane, using larger and denser ones for the base and some twisting and climbing ones for the sides.

As an experiment I choose a rough paper. The result looks quite lively, and I do not feel that the detail suffers too much from the roughness.

White roses

White flowers should not have a hard outline, even when they are painted without any leaves or flowers behind them. The shadows should be very delicate, lest the flower look dirty and heavy. The grays in the shadow areas should be carefully mixed as they will alter according to the color being reflected. There is a wealth of color in gray if you look closely – some grays, for example, are warm; some, cold.

With the rose, I start by painting the shadows, leaving small streaks of paper for the stamens. The grays I mix are light red with cobalt blue and lemon yellow, as well as cobalt violet with cerulean blue, which gives a slightly yellow gray, conveying the stamens' reflection. I then paint in the center and the stamens, accentuating some of the filaments with a touch of raw umber.

Later, as you can see in the detail of the finished painting, I position some leaves behind the roses to help throw them into relief.

Honeysuckle flowers

I usually draw honeysuckle flowers quite carefully before painting them as they are complicated. Here I leave the stamens white while painting the leaves and put a shadow of gray down one side afterward.

Outline of basic shape

White rose (initial stage)

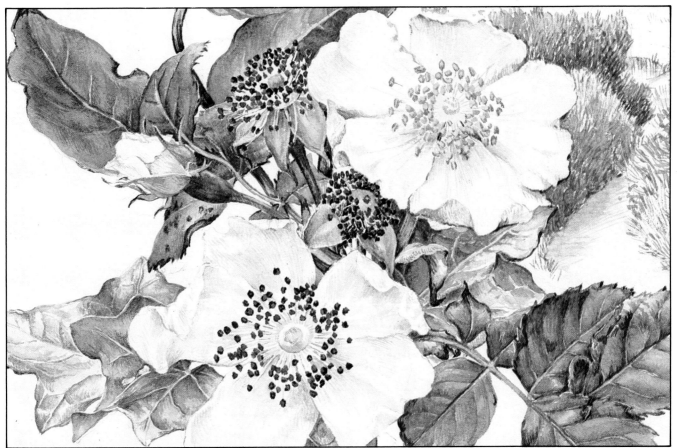

White roses (detail of finished painting)

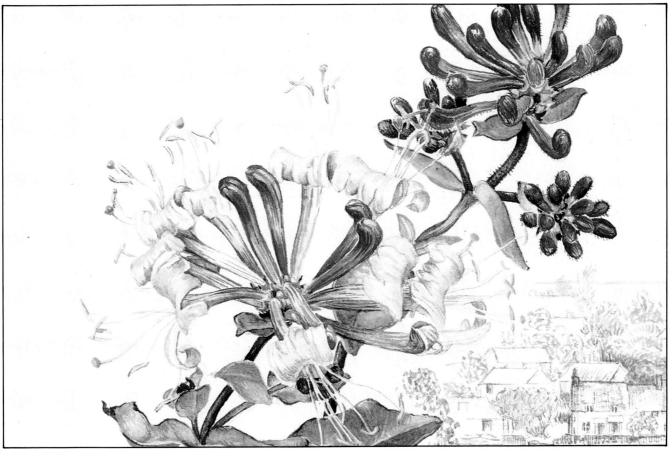

Honeysuckle flowers (detail of finished painting)

115

The finished painting

When the border of flowers has been painted, I sit in the lane and sketch the village. Although I could do this from a photograph, it is easier to see the details from life. First, however, I make a quick tracing over the painting to establish the positioning. I want the green bank and hedge to come behind the white rose and the lane to lead into the center of the picture, drawing the eye inward. I draw the scene with a gray made of cobalt blue and light red, adding more green-brown or ochre in the foreground.

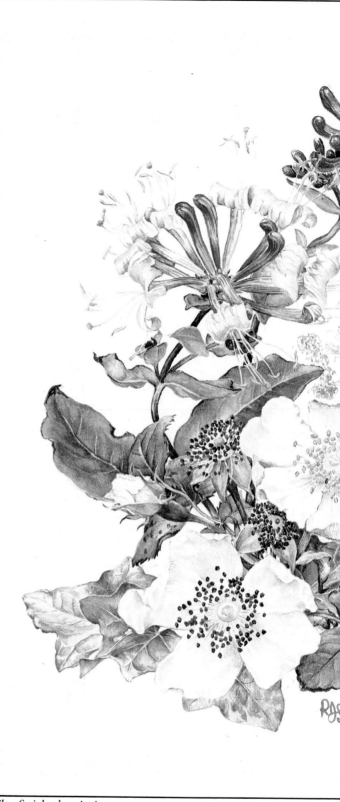

The finished painting

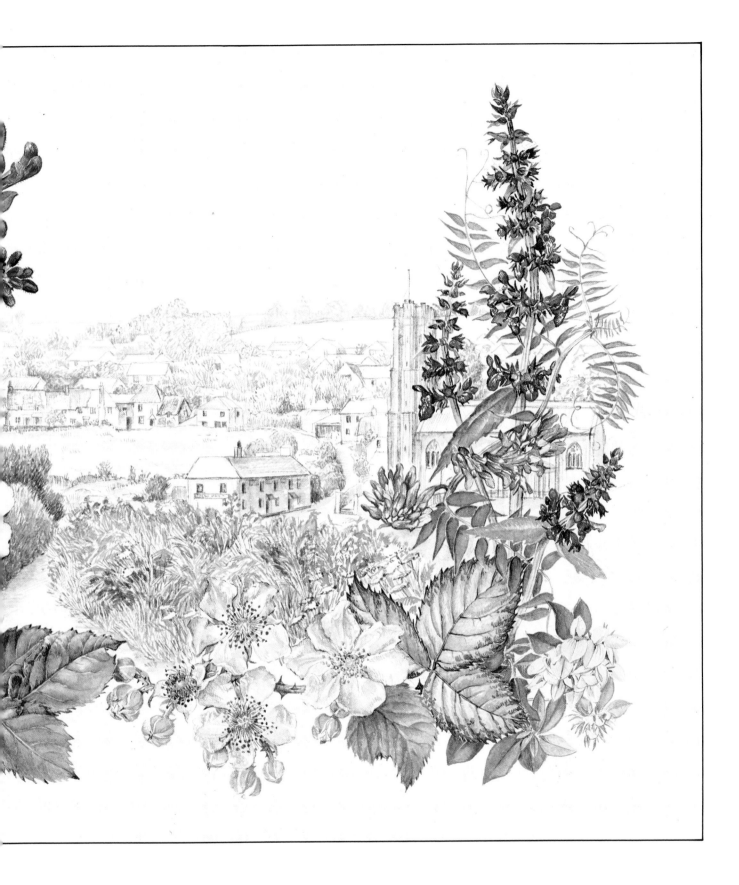

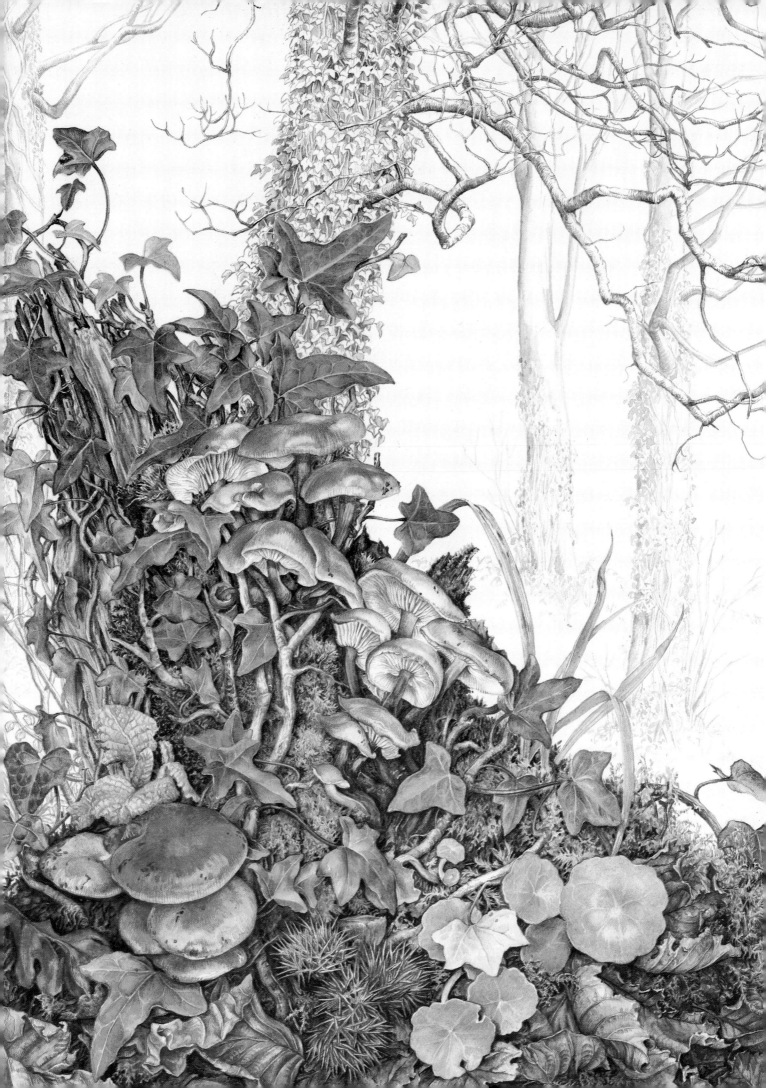

The tree stump

Snowdrops (page 120)

Size: 13¾ × 9¾ inches (350 × 248mm)
Paper: Whatman hand-made 80lb. (150gsm)
Brushes: sable nos. 1, 2

While walking in the woods during the winter, I came across this richly colored group of mushrooms called winter fungus, or *Collybia velutipes,* growing on a rotting elm tree. Their color provided such a marvelous contrast against the ivy and the moss covering the stump that I felt I must paint it. I always enjoy painting mushrooms and fungus because they offer such exciting shapes and colors.

First I removed part of the clump, with some ivy and moss still attached, and took it home with a few dead leaves and other bits and pieces that were lying around. I did not consciously compose this picture so much as simply begin with the mushrooms and continue from there. I found other leaves and plants to add as I worked as well as a piece of dead wood for the back of the stump. The trees I drew in last.

As with other paintings, I painted the leaves and mushrooms first and then filled the spaces in between with moss and twigs. To create the highlights on the mushrooms, I let the paper shine through, either by not painting that area and blending the wash around it, or by lifting the paint afterward. To give the glossy look on the lower left, I added a touch of cobalt violet. I never use white for highlights as it deadens the effect.

This painting took me about two weeks to complete.

Size: 9¼ × 6 inches (235 × 155mm)
Paper: Arches 140lb. hot-pressed (300gsm)
Brushes: sable nos. 1, 2

Near our cottage there is a small grove or copse which, during the early part of the year, is carpeted with ivy and snowdrops. The dark green of the ivy sets off the pure white of the flowers to perfection. I always think that snowdrops are best seen growing like this.

I took some photographs of the grove to remind me of the general situation of the flowers – at the time it was much too cold to sit in the woods and paint. Since snowdrops are a subject that I seem to paint frequently, I had a large clump growing in a pot, which I could bring indoors and use as a model to paint from. An alternative would be to dig up a group of flowers from the garden with a large section of earth still attached and replant them after finishing the painting.

After outlining the composition in a preliminary sketch, I began painting the foreground and worked my way to the back.

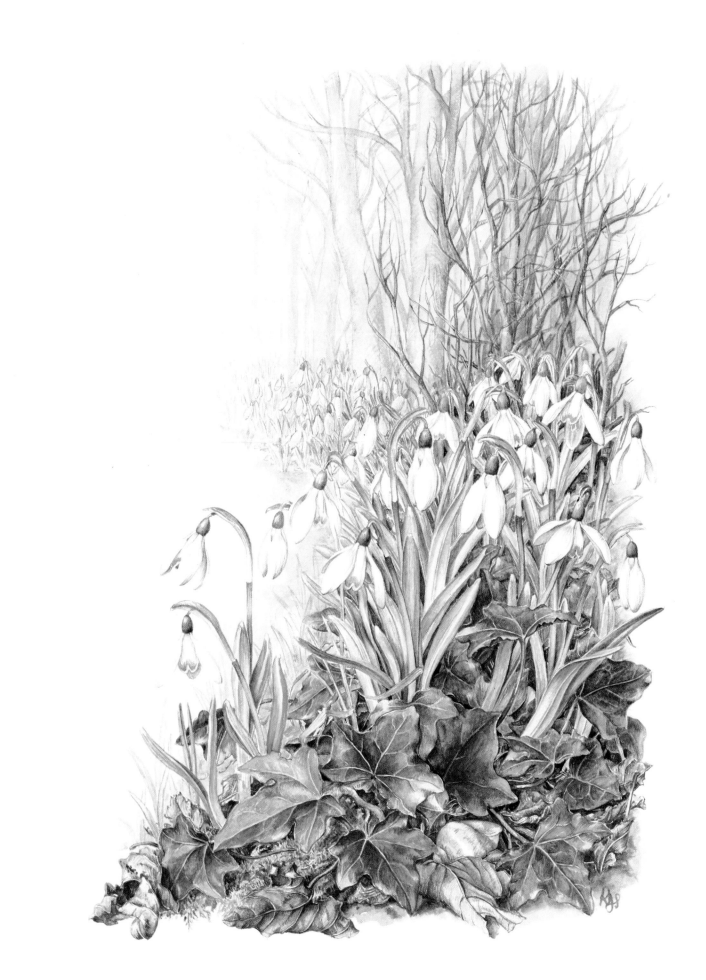

Summer cliffs

Size: 8-inch (20cm) diameter circle
Paper: Arches 140lb. hot-pressed (300gsm)
Brushes: sable no. 1

If you want to paint nature, it is essential to walk: you must get out among the flowers, or whatever subjects you want to paint, and experience them in their natural surroundings. What excites me as an artist is how whole worlds can be found in one small piece of hedgerow or bank. I actually tend to see my 'countryside' in small areas, maybe a few square feet. I am continually amazed at how nature, when left to herself, strikes a spontaneous balance of color and form.

The cliffs around our Devon shores are a tapestry of flowers in summer, carpets of campions, bluebells, and vetches, for example. I painted this circular picture in June, choosing a color group that appealed to me, including bloody cranesbill, bush vetch, milkwort, English stonecrop, sheep's-bit scabious, bell heather, and geranium.

Stage 1

Having decided to make a circular painting, I cut an 8-inch (20cm) circular hole in a piece of thin cardboard and lay the mount over the paper. This not only gives me the dimensions to work to but also protects the edges of the paper.

Next I slip scrap paper under the mount and roughly sketch an idea based on the flowers I have collected. I find it useful to have a sketch or photograph of the background scene to start with so I can fit the design in with the landscape. I do not always do this, but it helps to plan the overall composition. It is important to establish where the weight of the picture will be and to place some plant at that point to make a denser mass. I prefer the weight to be on one side or the other, not in the middle. The lines should then flow from this point.

Stage 2

I lightly draw the plants with a 2H pencil, continuously sharpening it to a fine point and pressing it very gently. It is not necessary to draw in every detail, just the main shapes and stems.

Stage 1

Stage 2

Stage 3 (detail)

Stage 4 (detail)

Stage 3

I start with whichever flower is likely to open out or wilt first – in this painting, the geranium. The illustration shows how I progress from the drawing, moving in a clockwise direction, to the finished petal. For the petals, I use a light wash of permanent rose mixed with a little cobalt blue, leaving the highlights white at first. I then blend some color into the highlight areas with a clean, slightly wet brush. When it is dry, I go over the veins and darker areas with a stronger mix of the same color and blend again. Then I overpaint with a little cobalt on the bluer areas and blend in. When this is dry, I accentuate the veins with alizarin crimson mixed with a little cobalt. I paint the center of the flower and blend the petals into it.

For the leaves, I choose a light wash of Winsor green mixed with yellow ochre, leaving the veins and highlights white. I blend in the highlights as before; then paint the darker areas with a stronger mix, using fine brushstrokes; and blend these together with a clean brush. Lastly, I indicate the veins with pale yellow and, when that is dry, slightly darken the shaded side of the veins.

Stage 4

When the geranium is complete, I paint in the stonecrop, starting with the flowers and painting them very lightly in pink, drawing in the stamens. I also paint the lighter leaves and buds in the appropriate color, adding some definition with a deeper shade. Then I fill the spaces in between with red-brown or green and, with a darker tone, draw in the form of the leaves. Finally, with a mixture of burnt sienna and French ultramarine, I cover the darkest areas and pick out the flowers.

With the sheep's-bit scabious, I begin by painting the pink anthers and then draw the petals with cobalt blue mixed with a little permanent rose. I draw the center of the flower with a slightly darker tone and fill in each petal with a light wash of the same color. When this has dried, I paint the dark areas and pick out the petals with French ultramarine mixed with a little permanent rose; then I paint the green sepals.

I use permanent rose with a touch of cobalt blue for the heather. I paint the darker areas and leave the highlights white, blending with a clean brush as before. I then pick out individual flowers with a deeper tone and draw the leaves with green. Each leaf I fill in with a paler, slightly yellower wash and, when it is dry, paint the stem between the leaves. I pick out the right side of some of the leaves with dark green.

Stage 5 – the finished painting

When the flowers have been painted, I lay some tracing paper over the painting and work out the background drawing. I draw the background scene using a no. 1 brush with a fine point and a gray mixed with cobalt blue and light red. The farthest cliffs are the bluest gray; this color gradually becomes warmer as I add more light red toward the foreground.

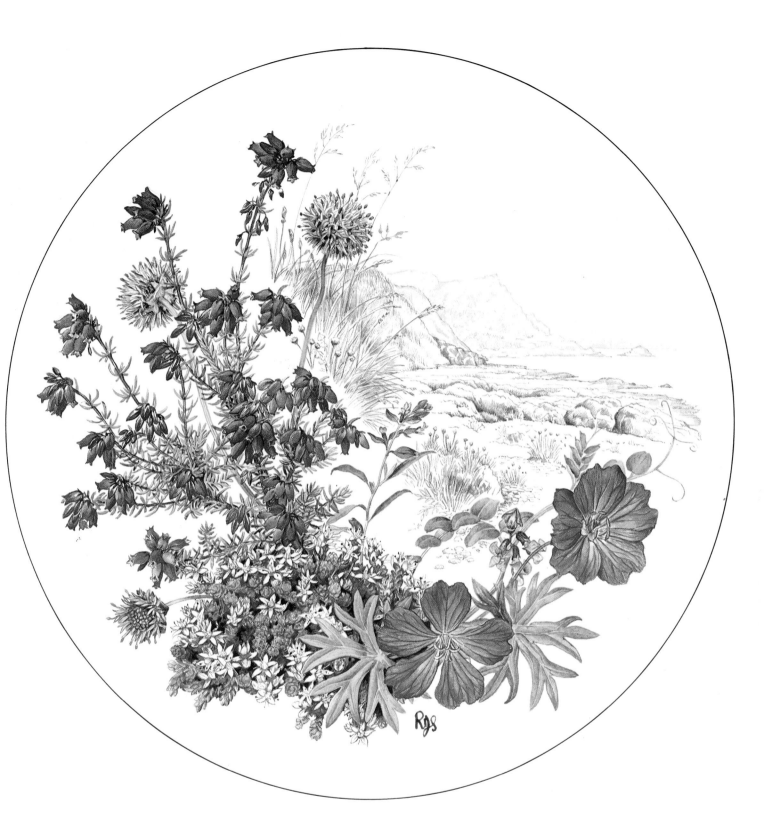

Stage 5 – the finished painting

Autumn woods

Size: 6¼ × 9 inches (157.5 × 222.5mm)
Paper: Arches 140lb. hot-pressed (300gsm)
Brushes: sable nos. 0, 1, 2

It was rather late in the season, and I wanted to capture some of the autumn leaves and fruits. Next to our cottage is a small wood, and I went there to see what I could find. Underneath some laurel and oak trees in the center of the wood, I found quite a variety of small toadstools among the leaf litter. I gathered some of these in a basket, together with some oak leaves, a rather splendid laurel leaf, and some twigs and ivy.

If I am painting something that is commonly found, not rare or endangered, I prefer to take the subject home and paint it indoors. In autumn or winter, the weather is often too cold or wet to sit for long hours at a time, while in summer I find working outside too distracting. In addition, I find it uncomfortable as I like to sit very close to my subject.

Composition

Here my composition focuses on the toadstools. I have several small ones of more or less the same size, and I choose two separate groups of different colors, as well as a single, distinctively colored toadstool. I position these on a tray, scattering the leaves and twigs around them so that they look much as they did when I found them.

On separate pieces of tracing paper I draw the three groups and place these tracings on a blank sheet of paper, ruled to the required measurements of my painting. I intend to fill the entire foreground with leaves, but want to keep an oval shape in the background, where I plan to suggest the woods in monochrome.

When I have composed the three groups as I want them, and have altered the arrangement on my tray accordingly, I lay another piece of tracing paper on top and roughly draw in the areas where the leaves will go. I stick all these pieces of tracing paper firmly onto the backup sheet and keep this as a reference while working on the painting.

Stage 1

After drawing the three groups of toadstools, I start with a light wash and leave the white paper for highlights. Gradually I build up the color with drier paint, using fine brushstrokes and working in layers to the darkest tones. To create a three-dimensional appearance, I let the direction of the brushstrokes follow the form of the subject.

The drawing is of my original plan of shaded and detailed areas. I intend to fill in the foreground with leaves and keep an oval shape for the background.

In the top toadstool, you can see the light washes with the colors blending together. Also notice that the highlights and edge between the cap and stem are left blank. The left toadstool shows the further addition of drier paint, while the direction of the brushstrokes suggests the grooves in the cap.

For these toadstools on the left, I use cobalt violet, cobalt blue, lemon yellow, and raw umber. For the center toadstool I work with cobalt violet, cobalt blue, and raw sienna, as well as Winsor violet on the darkest edges. Finally, for the group on the right, I use cobalt violet, light red, and raw sienna.

I leave the toadstools on the light side as they can always be darkened later, if necessary, when the background is put in. I also leave the base of the stems indefinite, in order to blend them in later.

Stage 2

I now begin on the bottom foreground – it does not really matter where. Using the same principle as before, I first draw the main structure of the leaf with a light brush-line; then I lay in a basic wash, leaving the white paper for the highlights and veins of the leaf.

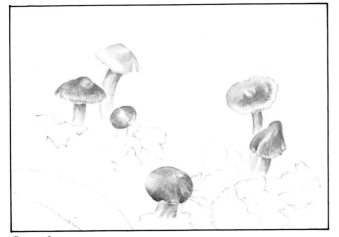

Stage 1

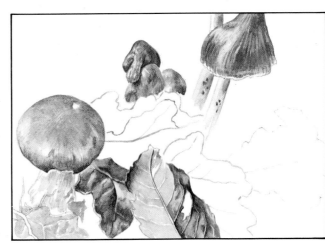

Stage 2 (detail)

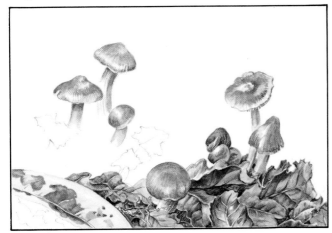

Stage 3

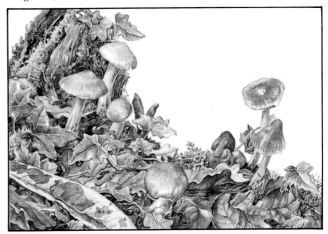

Stage 4

Stage 3

I develop the entire foreground leaf by leaf, painting the in-between bits as the surrounding leaves are completed. This process allows flexibility in the setup. Leaves can be replaced if they look too dry. It is also helpful to spray them with water.

For the foreground leaves, my palette includes raw sienna, raw umber, cobalt blue, cobalt violet, light red, French ultramarine, aureolin, and burnt sienna. Cadmium yellow, cadmium lemon, and lemon yellow are also used for the laurel leaf.

I usually find it is better to mix a black than to use a ready-mixed one, which can look rather dead. A good blend is French ultramarine and burnt sienna. Here, however, I do use a touch of lamp black to strengthen *small* areas of shadow.

Stage 4

By the time I finish painting the foreground, the leaves on the tray have become dry and dull. So I collect some more, together with ivy and part of a tree stump with moss. After setting these up on the tray, I proceed as before. The additional colors I use are viridian, Winsor green mixed with raw umber, and cyanine blue.

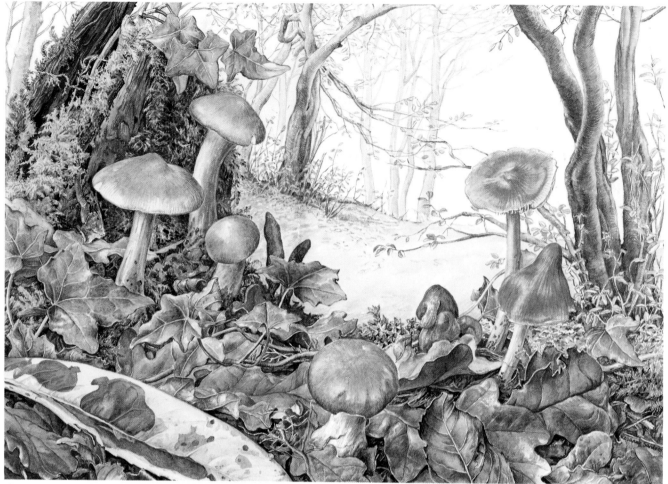

Stage 5 – the finished painting

Stage 5 – the finished painting

Once the detailed areas are finished, I go into the woods with the painting and finish the background *in situ*, after doing some preliminary sketches on tracing paper over the painting. The light grays are made from cobalt blue and light red; the dark grays, from French ultramarine and burnt sienna, with some viridian.

Bluebells

Size: 11½ × 8¾ inches (292 × 222mm)
Paper: Arches 140lb. hot-pressed (300gsm)
Brushes: sable no. 1

Whatever the season, there is always plant life to be found among the hedgerows or in parts of the garden. It may be moss or ferns, dried leaves or mushrooms, grasses or wild flowers. Here in Devon during the spring the choice is overwhelming. The banks are covered with primroses, ferns, violets, and celandines, followed by bluebells, wild garlic, foxgloves, campions, and the occasional wild orchid, to name but a few.

For this painting I select some of these spring flowers and try to capture the tangle of growth that the banks often show. My palette consists of cadmium lemon, cadmium yellow pale, aureolin, yellow ochre, raw sienna, light red, burnt sienna, permanent rose, alizarin crimson, cobalt blue, French ultramarine, Winsor violet, and Winsor green (*never* on its own but always mixed with yellow ochre, light red, raw sienna, or aureolin with a touch of light red).

Stage 1

I begin by sketching a clump of Hart's tongue fern and a few bluebells on a piece of rough paper. What I want is a rough idea of the shape that these plants suggest and the lines of the eventual composition around them.

Stage 2

I paint the main subjects, taking care not to overwork them at this stage and leaving them on the light side. They can always be darkened later, but, if they are too dark to begin with, the sense of depth may disappear and everything end up too dark all over. I also leave the base of the stems unpainted, so I can work them into the other plants later on.

As you proceed with your own picture, think of how to balance the colors, so as not to have all the intense colors on one side. You might even make a rough color sketch, with just blobs of color, before you start the painting, to work this out in your mind.

Stage 1

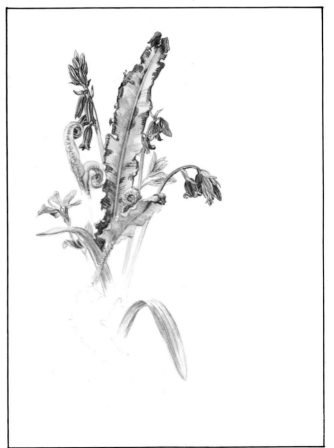

Stage 2

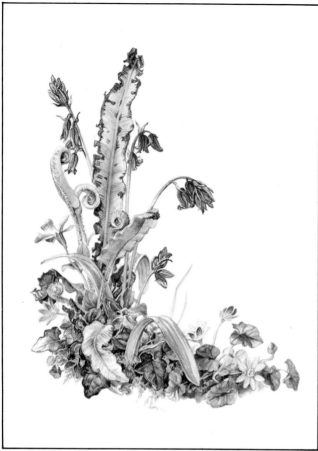

Stage 3

Stage 3

Following my original plan (see Stage 1), I develop the picture as an isolated group of plants set within the frame. When I reach this stage, however, I change my mind and decide to paint right up to the edge of the paper, with some items extending beyond the frame (see the finished painting on page 131). I think this will make the painting look more natural and less of a 'set-piece'. I do not believe it matters if you change plans in midstream; the picture inevitably grows as you work on it and sometimes your ideas do change.

Stage 4 – the finished painting (page 131)

Study the detail of the finished painting on page 129 to see how the lights and darks relate to one another. Where there is a dark area on a foreground leaf, such as the underside of the bluebell leaf curving toward you, then the leaf behind is lighter. If, on the other hand, the foreground leaf is light-colored, the ones behind appear to be darker. If there are two dark patches together, there is nearly always a small thread or patch of light on one or the other, which gives the appearance of depth.

On your own, study the leaves on a house plant. Carefully examine the contrast between the light and dark areas. Notice how they relate to one another and why one leaf appears to be in front of another.

It is well worth studying the paintings and technique of Redouté, the great French painter of botanical plants for he succeeds in creating a marvelous sense of depth.

Stage 4 – the finished painting (detail)

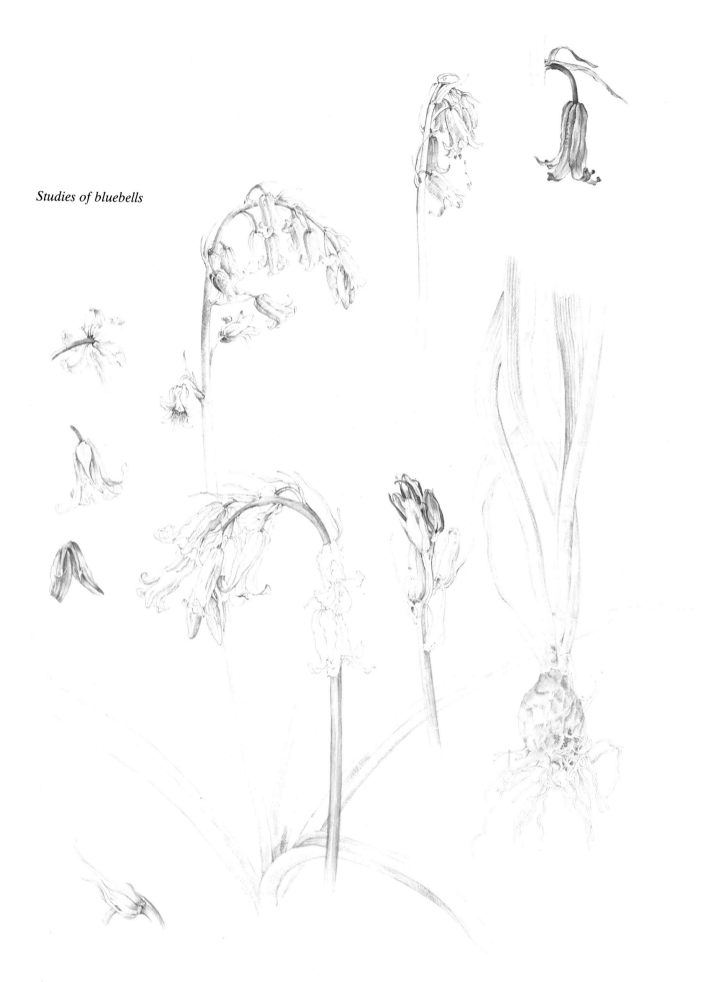

Studies of bluebells

130

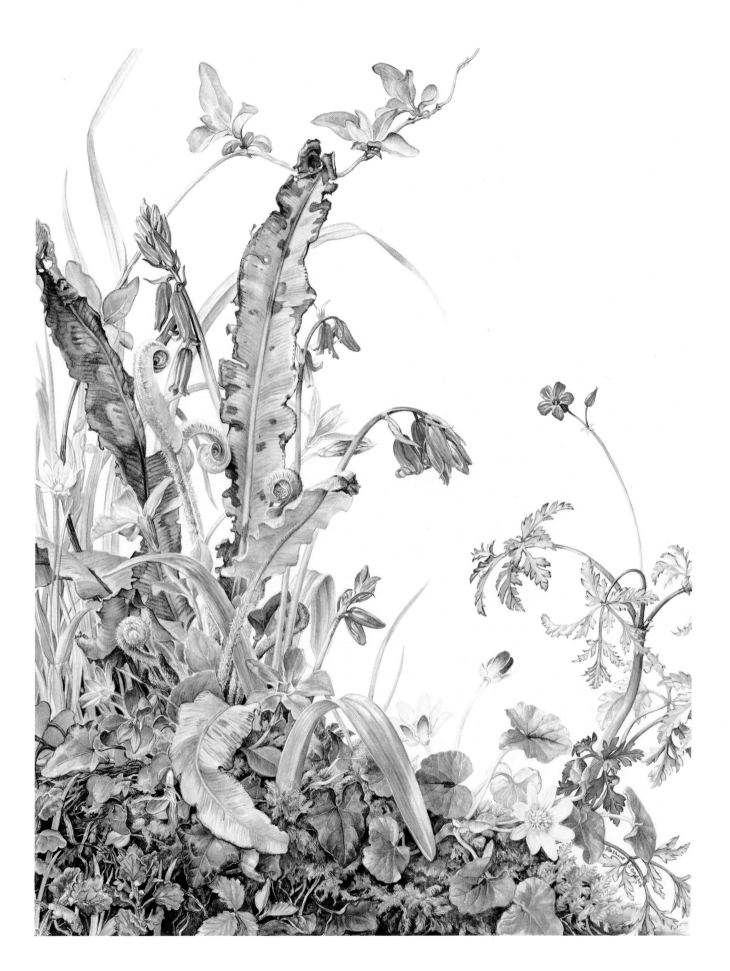

Stage 4 – the finished painting

Seasonal theme picture – Autumn

Size: 11¾ × 8½ inches (345 × 212mm)
Paper: Arches 140lb. hot-pressed (300gsm)
Brushes: sable no. 0, 1, 2

This painting is one of a set of four seasonal pictures. I have again taken the lane outside my cottage, but here I paint typical flowers and plants for the season as a border, with a view from the lane in the center. I do not plan the picture carefully, except to draw the outer dimensions and the center oval. I choose a fairly substantial base for the picture and, starting with that, try to keep the colors balanced.

I paint the berries first and the foliage beneath, then the piece of wood with the toadstools. Next I paint the top two corners, leaving some trailing plants to come down each side. Other things can always be added later so it is best not to fill in too many leaves at first; for instance, the two leaves behind the berries are added later as well as the grass on the left side. In the places where I may want leaves or stems to appear behind something else, I just draw them in, until I decide where they are to go.

If the paper is good, and the paint not a staining color or dye, such as sap green, the paint can be lifted from a leaf, for example, to make a stem appear in front. Lift the paint with a brush and clean water; then, when the area is dry, paint the stem. In the example opposite, the leaf on the right is painted with Winsor green mixed with yellow ochre and a touch of aureolin, which has not lifted completely but enough to paint in the stem on top.

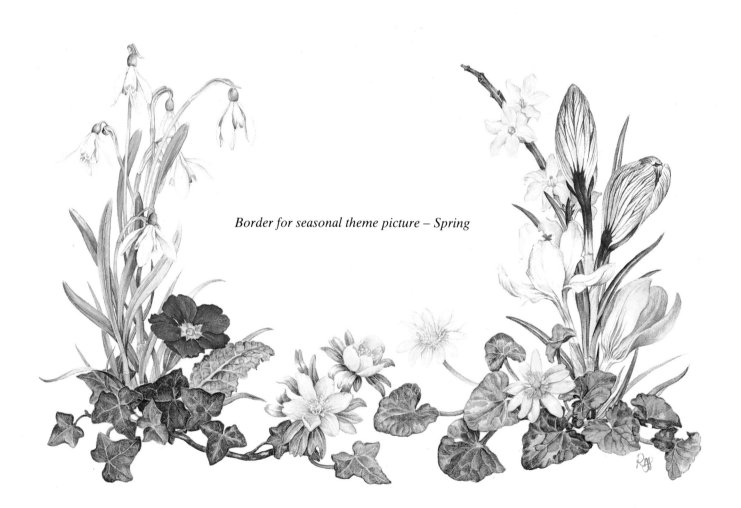

Border for seasonal theme picture – Spring

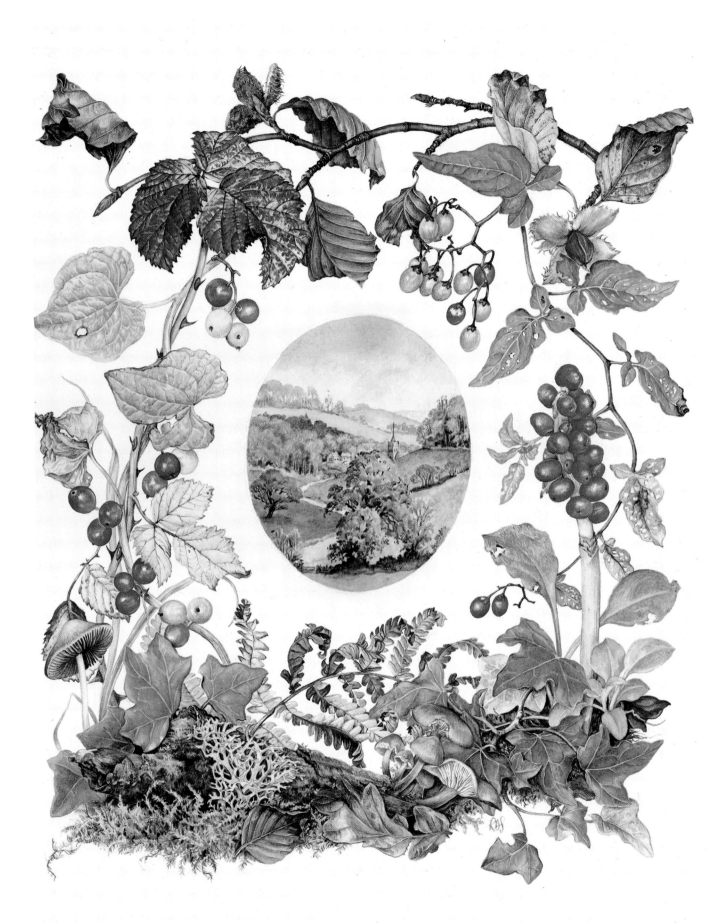

From my sketchbook

Whenever possible I try to do some sketching. Not only is it useful to build up reference material for future use but doing working sketches of flowers makes you study the subject closely from different angles and deepens your understanding of how the plant is put together, its anatomy in fact. In order to examine and draw the whole plant, it can be dug up from the garden, the roots washed and replanted after drawing without too much damage, but I do not advocate this treatment with wild flowers.

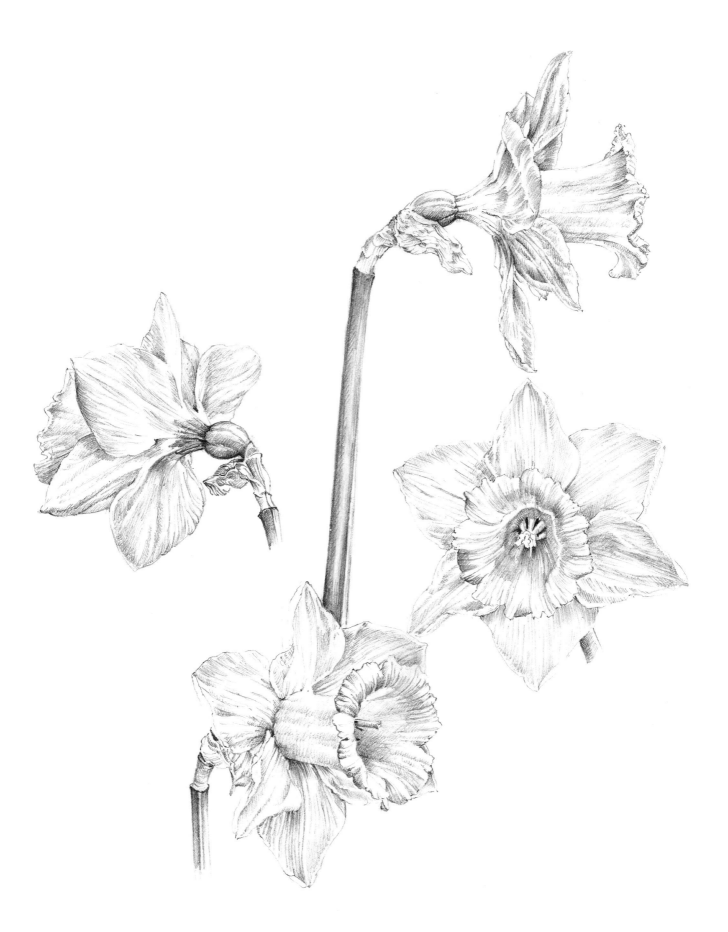

Mushrooms

Several years ago I went on a 'fungus foray' (a sort of mushroom hunt) given at the Field Studies Council Centre at Flatford Mill in Suffolk, real 'Constable Country'. It was a marvelous week. Every day after breakfast we visited a local wood, where we spent the morning gathering and identifying mushrooms. My main objective was to paint the samples that I found, so I looked for mushrooms that appealed to me either by color or shape.

Afterward, in the laboratory, our group examined the samples through microscopes and took spore prints. Later I went with my paints and sketchbook out to an island nearby and made twenty-minute sketches of as many mushrooms as I could.

During the evening I drew cross-sections of each subject and recorded information about its size and habitat, for example. By the end of the course I had many sketches as both a pictorial record and a reference, and I have used a number of them in my paintings.

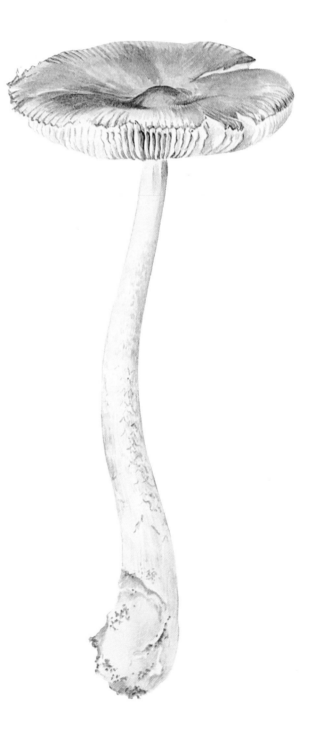

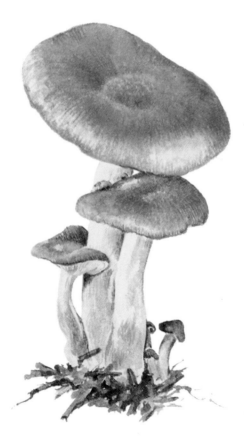

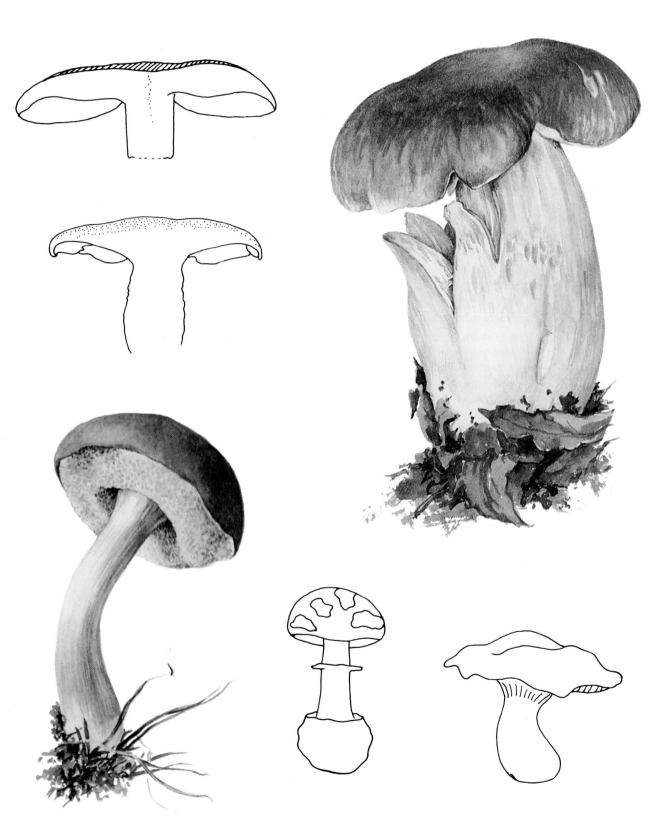

About the Authors

SYLVIA FRATTINI was born in Cumbria. She trained at Carlisle and Hornsey Colleges of Art, and now lives in Buckinghamshire. She is Head of Art at a High School in Luton. She has had several one-painter shows, and regularly exhibits in the Royal Academy Summer Exhibition and the Royal Institute of Painters in Watercolour.

JAMES LESTER has spent many years as a freelance art director and illustrator. He has painted throughout his working life and, in recent years especially, in watercolour which has taken over from much of his other work. He regularly exhibits at London galleries and he has had a one-man exhibition in Kent. He works in watercolour because he feels the inherent qualities of the medium are so much in sympathy with the nature of the English landscape.

BENJAMIN PERKINS born in 1932, was educated at Sherborne, Trinity College, Oxford, and studied rural estate management at the Royal Agriculture College, Cirencester. He now works as a painter and writer, and has had two books published, *Trees* (1984), the painting and drawings in which won him an RHS Gold Medal, and *A Secret Landscape* (1986). He lives in Suffolk.

ROSANNE SANDERS was born at Stoke Poges in Buckinghamshire and grew up in the country. She was educated at Roedean, and after that took a one-year basic course at High Wycombe College of Art, but, as she did not paint for many years thereafter, she regards herself essentially as self-taught. After buying a Devon cottage she wrote and illustrated *Portrait of a Country Garden* (1980). She has exhibited at the Mall Galleries, at the Royal Academy Summer Exhibition, and in Tunbridge Wells. She has won three gold medals for watercolours from the Royal Horticultural Society, and a Royal Academy Miniature Award

139

Index